My Month With Banksy: October 2013 in NYC

Jacqueline Hadel

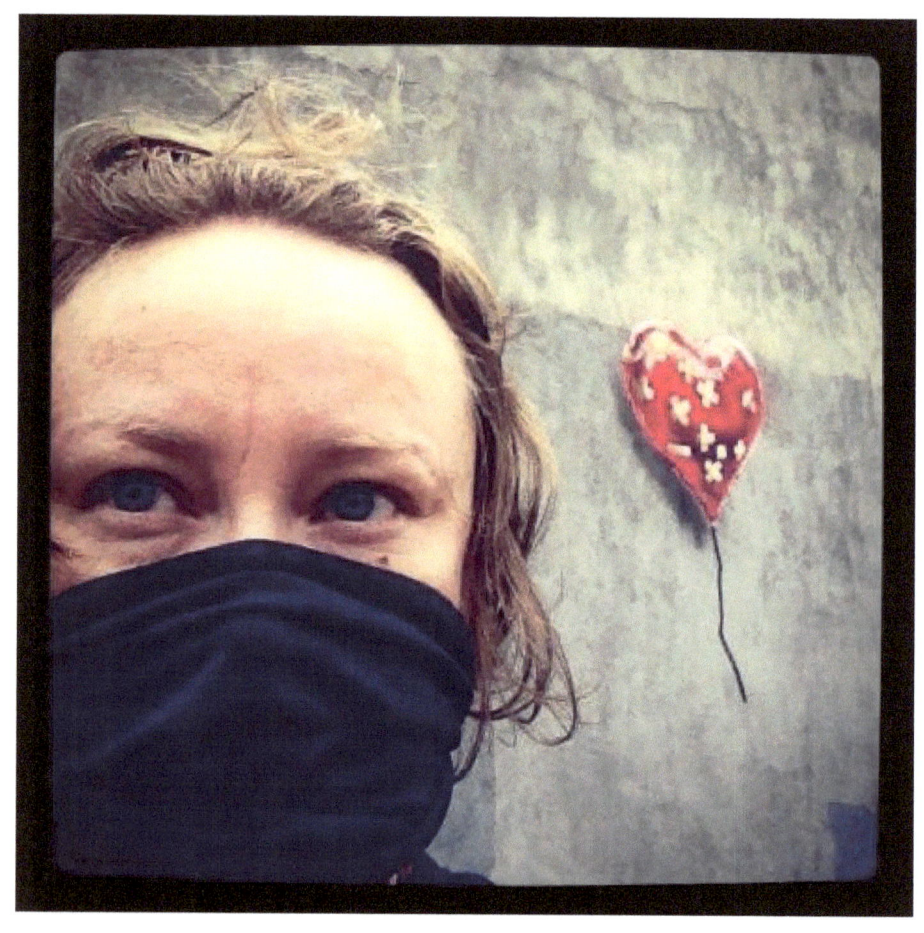

Copyright ©2013 Jacqueline Hadel

All rights reserved.

ISBN-10:1494258447
ISBN-13: 978-1494258443

DEDICATION/ACKNOWLEDGMENTS

This book is dedicated to Banksy for waking up a city and for encouraging connectedness through art. So many people throughout the month made comments like "Man, I've never been to this part of the city before. It's really cool."

…the Pest Control Office, Joseph Meloy, Jermaine K. Bell, Robert Stevens, StreetArtJamz, Emmanuel Laflamme, Miggity Mac, RLexist, Capnyc, JenitaBonita, and to all of the other awesome people I met, that I can't remember the names of right now, that made this month even more special. Why can't I remember the names? Well, sometimes names weren't even exchanged. We just nodded a knowing greeting to each other or 'liked' each others' Instagram pics. The connection is still there, name or not.

Thanks also to my friends, the most supportive in the world. If I didn't have you, I couldn't do what I do.

All photographs are originals by Jacqueline Hadel, unless otherwise noted.

NB It's BankSY. Not, BanSKY. Please…

CONTENTS

	Dedication/Acknowledgments	i
1	Preface	1
2	Week 1	Pg #2-13
3	Week 2	Pg #14-31
4	Week 3	Pg #32-44
5	Week 4	Pg #45-58

PREFACE

I had no idea Banksy was going to do this first-of-its-kind "residency" in New York City in October 2013: "an attempt to put out a piece a day for the whole month." I just happened to have been there and couldn't believe my luck. I've always loved Banksy's work, but never actually saw an original piece of his. Now to think that I would have a whole month of opportunities to see his work! I couldn't believe it.

I had already purchased a ticket to fly out of NYC on Wednesday, October 23rd. Decisions, decisions. Do I leave by justifying that I got to see and experience more than my fair share of this incredible Banksy experiment or do I eat the ticket and buy another one to fly out on November 2nd? I had no place in the city to stay, so I basically squatted illegally. I was sacrificing a lot for Banksy, but my crazed mind was cool with all of it.

1 DAY 1, OCTOBER 1ST: GRAFFITI IS A CRIME

And he's off to a cheeky start. I didn't even hear about it until after the piece had already been defaced by a graffiti writer who is pretty prominent in that area (Lower East Side); leading to the idea that Banksy must have stepped on his turf. And we'll come to see that Banksy is not respected by the tried and true New York writers at all. This fact intensified this 'scavenger hunt,' which is essentially what it turned into, adding stress to the whole experience. Now, every day, you were going to have to race to the piece once its address was announced, because there was a good chance it would be destroyed by the time you got there. It became an adrenaline-fueled race against time and malicious taggers. I resented this at first until I started to recognize the genuine sense of achievement and appreciation I would feel for each piece as I got there before the vandals did.

Since I didn't get the original first piece, I never forgot about it and I eventually went to see what was left of it, what it turned into. Here it is on October 9th. Images on next page. If you look closely, you can see that what was whitewashed over was the image of two boys, one standing on the back of the other, to cross out a sign that says "Graffiti is a Crime." Hence, my reason for calling it a cheeky, auspicious start. This piece is/was located on Allen Street in the Lower East Side, NYC.

2 DAY 2, OCTOBER 2ND:
THIS IS MY NEW YORK ACCENT

I couldn't believe my luck with this one. It was in Chelsea quite near where I worked, so at lunch time, I raced over to see it. Banksy humor:

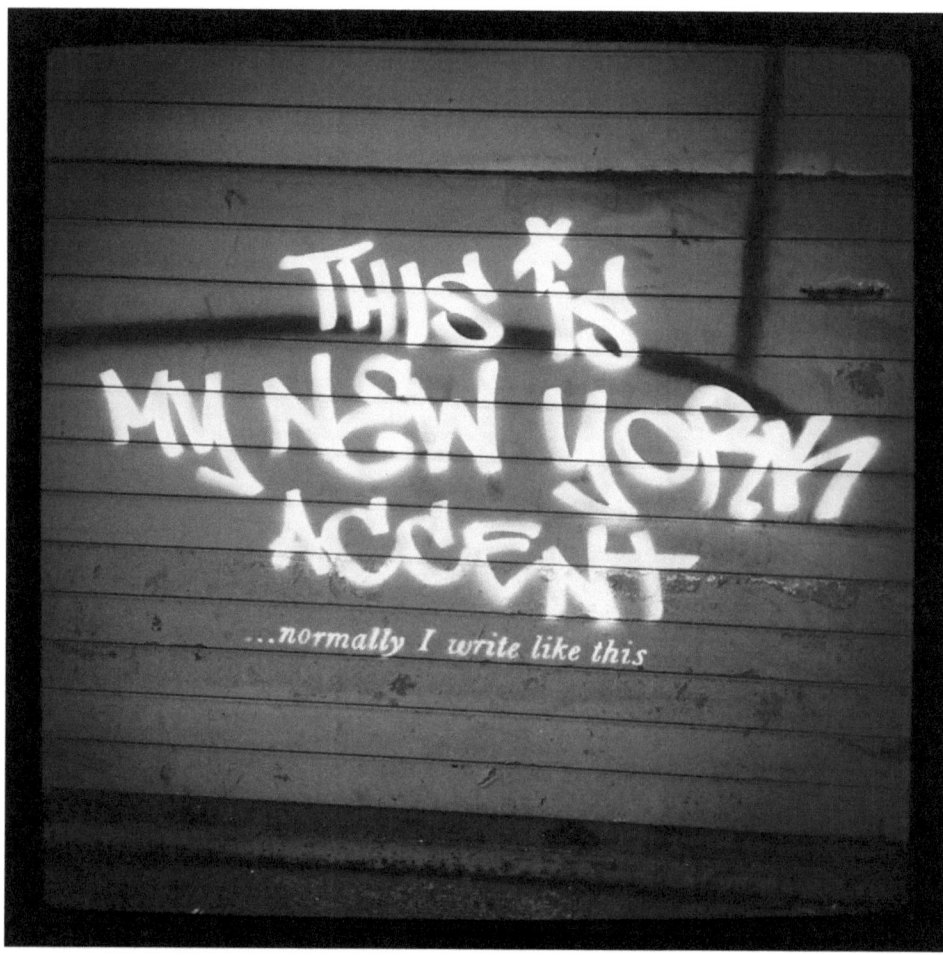

Some more sides to the piece on the next page, as well as the beginning signs of the throngs of people that would soon gather regularly at the various sites throughout the month. The piece did get tagged over later that night, but not before I shot it.

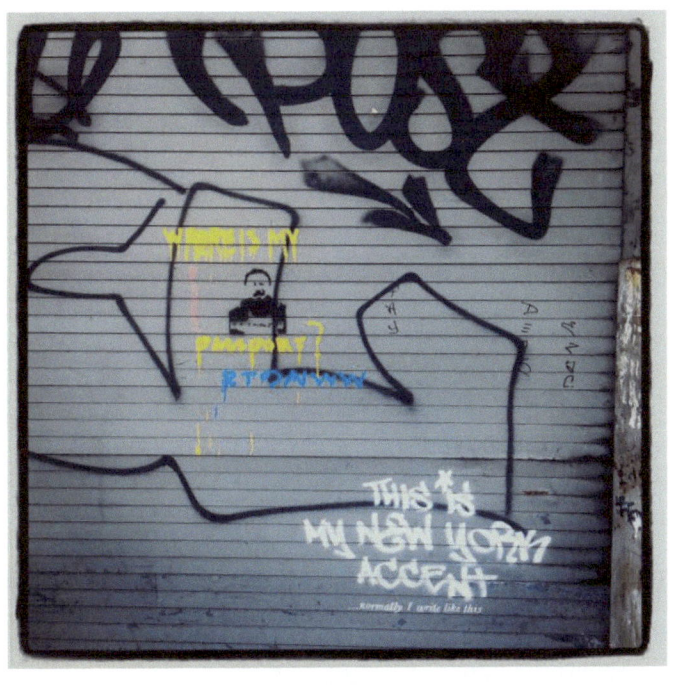
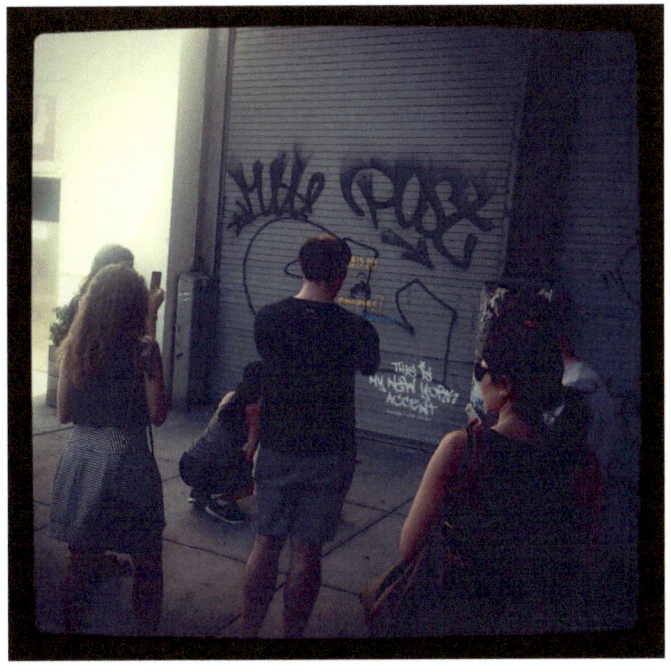

3 DAY 3, OCTOBER 3ᴿᴰ: YOU COMPLETE ME

Every fire hydrant's sentiment to propped up dogs settling in for a wee. Another lucky one for me that day, as I was able to go over to this midtown site during my lunch break yet again. Banksy had yet to go psychotic in all of the far-reaching Bronx and Queens locations. If he had, I would have been S.O.L. that first week. What I vividly remember about this one is that a local artist Joseph Meloy, had gotten there earlier and pasted his "primate" character near the piece. As much as I love Banksy, I still love the "primate," of New York City, too, so I ended up explaining the "primate" to the gathering crowd, as I had interviewed him for my blog a few weeks earlier. I loved that he had placed it next to the Banksy piece. Very smart. And others would soon follow suit.

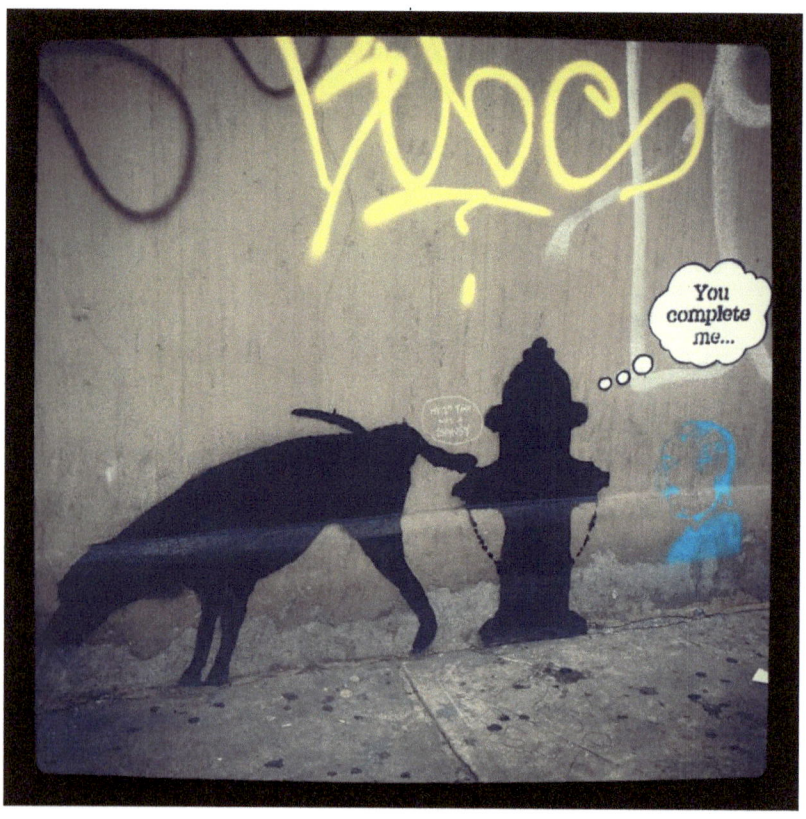

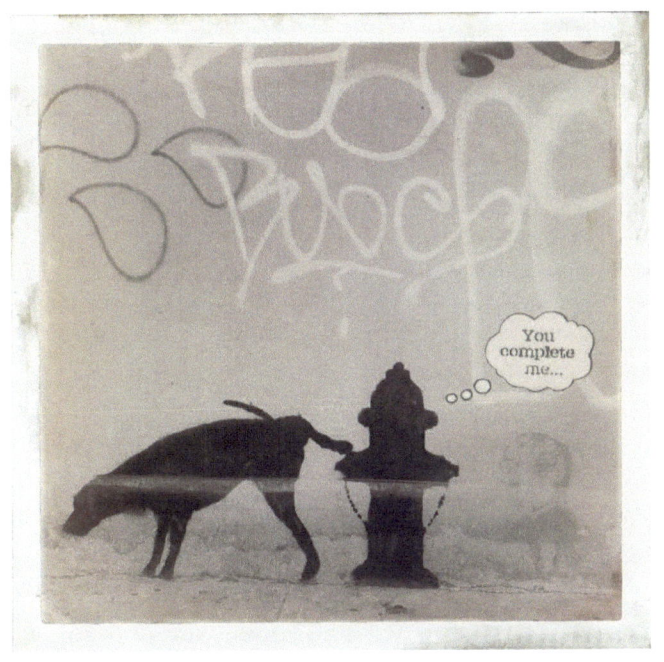

and with the addition of the primate:

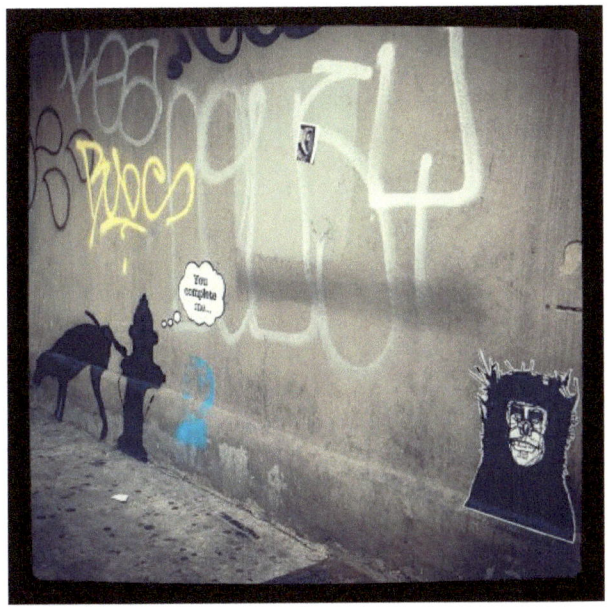

4 DAY 4, OCTOBER 4^(TH): PLAYGROUND MOB, THE MUSICAL

Things really started getting interesting for me after this day. This piece was located on the corner of Bowery and DeLancey in the Lower East Side. It was my last day of work, so I ran over afterwards and stood at this piece for quite some time. I was happy to be looking at an untouched piece and was just taking it all in. I remember a group of kids kind of eyeing me, wondering why I kept looking at it for so long. But, I didn't care.

Banksy had basically added "The Musical" to three existing tags around the city that day. This was the one I chose to document.

As I was standing there, three guys rode up on "Citibikes," (the city's public bike exchange) and hung out for a second. At first, it appeared that the one guy was walking up to the piece to have his picture taken beside it. Naturally, I was still taking pictures. Before I knew it, as his back was to me, I began to see gold spray paint coming out from where he was facing. At that point, he turned around and tried to pull his t-shirt up over his face because he knew people were taking pictures of him. A man ran over to try to pull his t-shirt down and kept asking, "Why are you doing this?" The vandal didn't say anything. He just stumbled and fumbled around for his bike to try to make a valiant getaway.

That hardly happened. He was weaving away uncontrollably like a four year old who just got his training wheels taken off. I cannot believe that he didn't crash and burn.

Here is the original untouched, then the vandalism in action, and finally, the tagged final product. Pictorial on the next few pages:

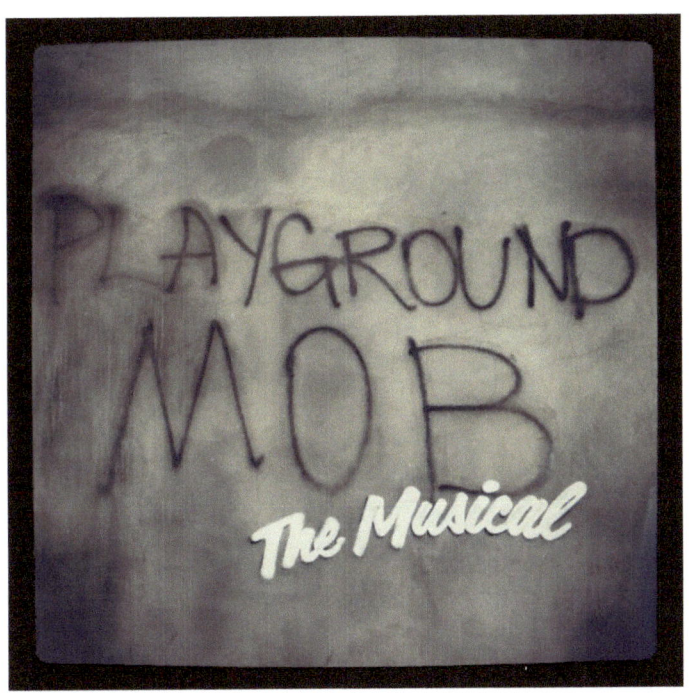

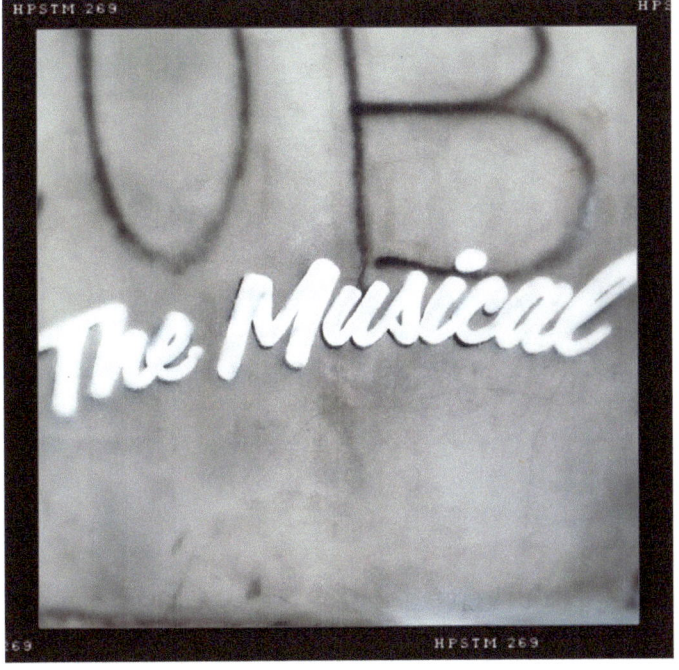

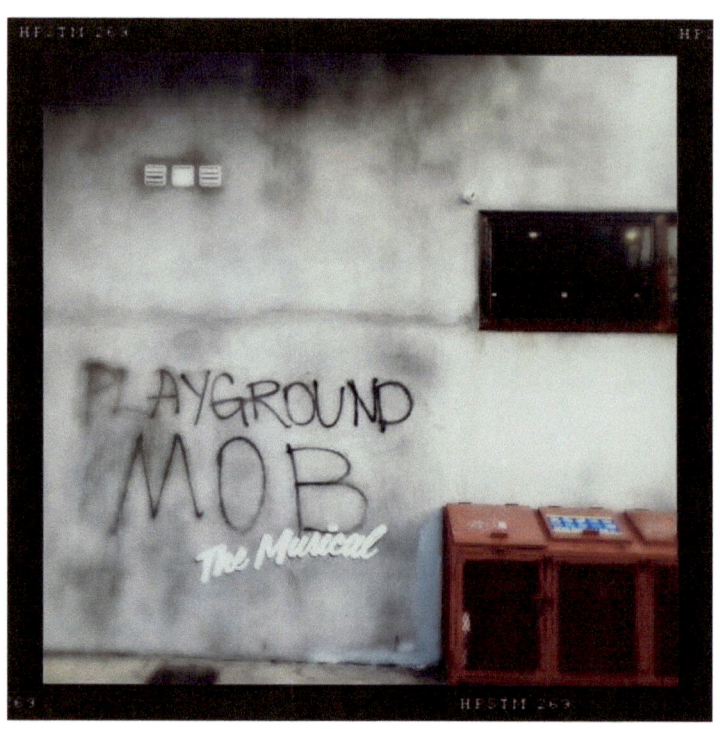

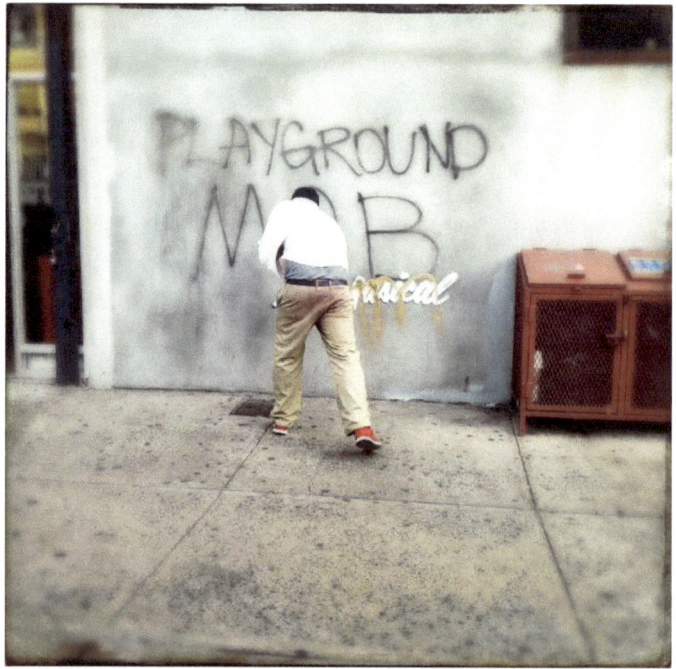

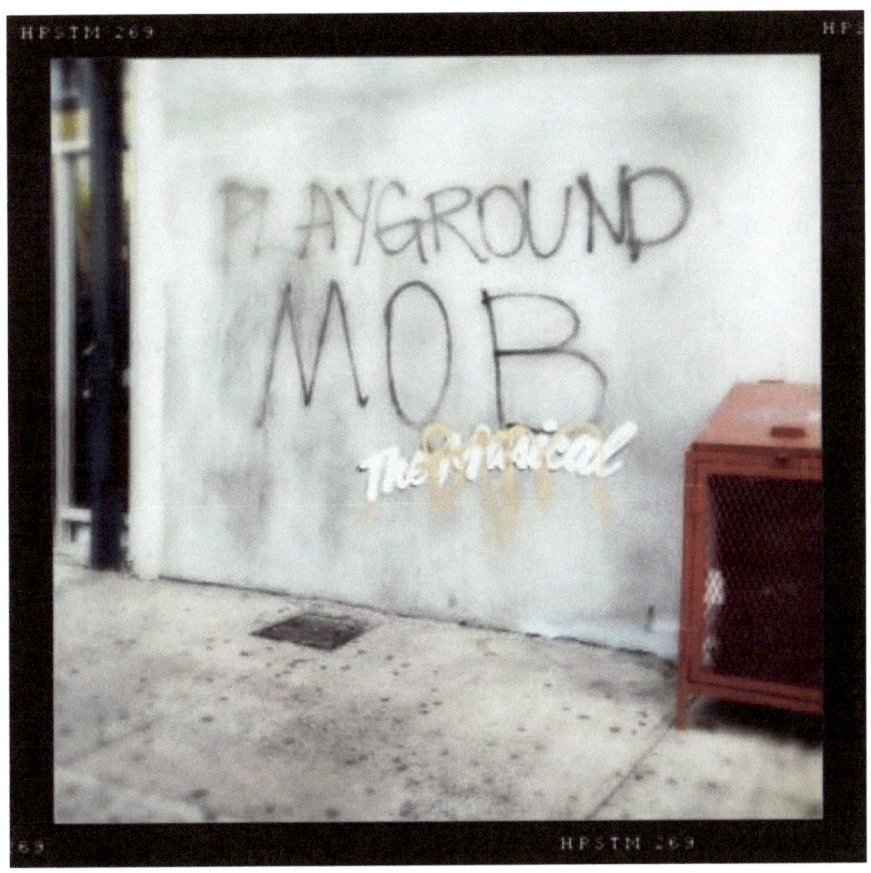

This was the first time I started getting some press recognition. After my pictures of the vandalism in progress went out on Instagram and Twitter, the emails started coming in for interviews and permission to use my photos.

5 DAY 5, OCTOBER 5TH: MOBILE GARDEN

A New York delivery truck was converted into a "mobile garden" that included a rainbow, a waterfall, and butterflies. I didn't catch it, but I'm OK with that. I'm more of a fan of Banksy's stencils that represent some kind of political or societal commentary.

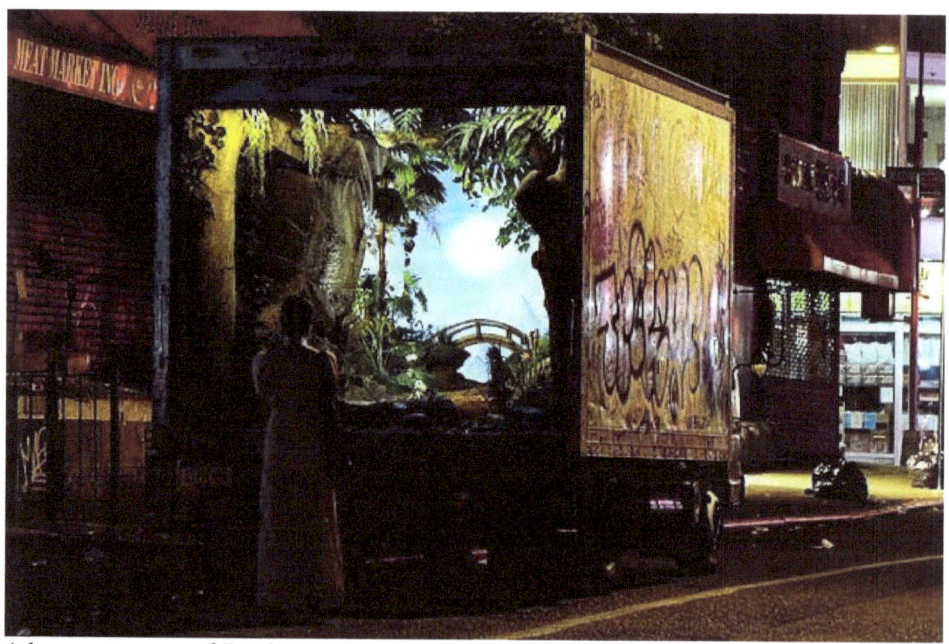

(photo courtesy of Banksy's website)

6 DAY 6, OCTOBER 6TH: REBEL ROCKET ATTACK

This was a real 'day off' from the hunt. All Banksy did on this day was, post a video on YouTube called "Rebel Rocket Attack." The video shows what appears to be Islamist rebels shouting in Arabic, pointing at something in the sky . The viewer has no idea what they're getting ready to launch a rocket at, we can only assume the U.S. military…and then at the end of the clip, Dumbo, the cartoon elephant, falls from the sky. Funny and random, yet, clever at the same time. Some Banksy fans took it as a clue that there may have been an actual Banksy piece up that day in D.U.M.B.O., a neighborhood in Brooklyn. So, they went searching. There wasn't.

7 DAY 7, OCTOBER 7TH: BALLOON HEART

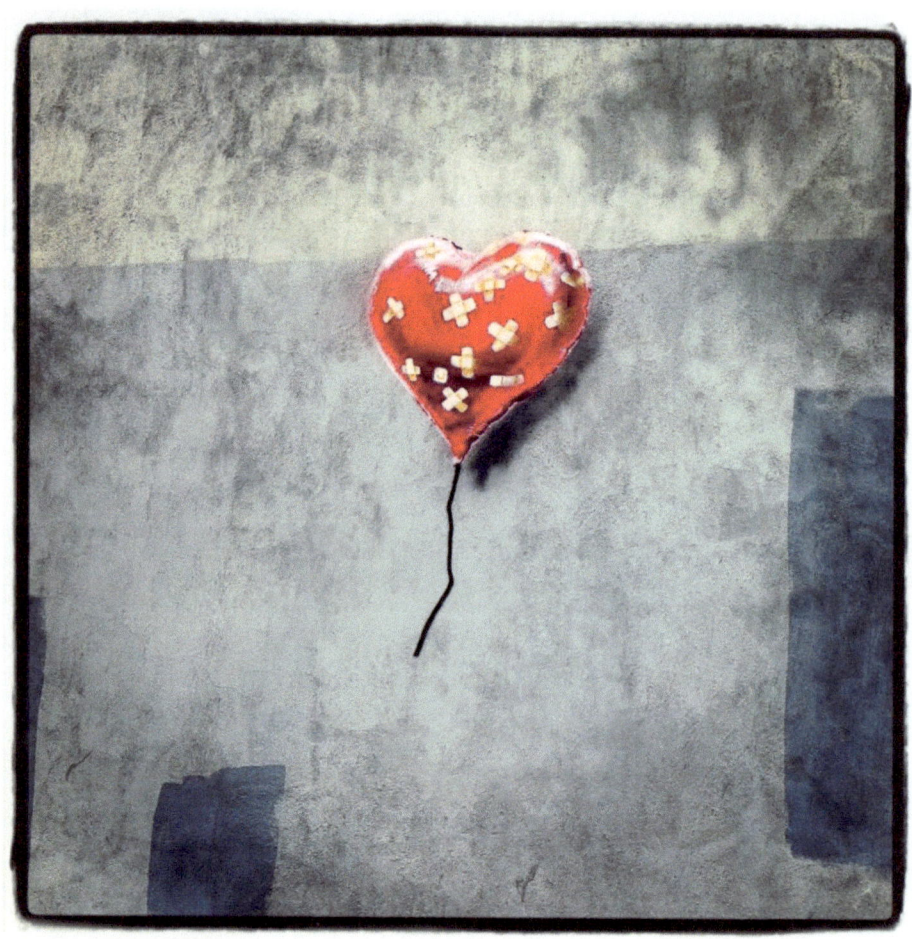

I had a difficult time getting to this one in Red Hook, Brooklyn. It involved trains, busses, walking, and maps I couldn't understand. Plus, I didn't feel well at all. When I finally hopped off the bus, there was just a small crowd gathered. It was so intimate that there was finally an opportunity to meet the other Banksy fans that I had been seeing previously at the other sites, but never really had the chance to interact with them.

Out of nowhere, an NYPD officer stepped to the forefront of the crowd and began snapping a picture with his phone. I remember saying to people as I moved to get closer to him, "Watch out! Let me get a picture of the police officer taking a picture of vandalism!" I said it loudly and purposefully, because what could he do about it? Maybe a lot, but I had it in my head that if he was there taking a picture of it as a fan himself, then he couldn't do anything to me for taking a picture of him. The photo I captured of this moment, ended up being perfect. The police officer is holding his phone up to take a picture and the balloon heart is clearly displayed in his frame. Snap! Just perfect. And as quickly as he appeared, he left. I knew that I had a great shot and it made the tough day up to that point well worth it.

By the time I got home that night, the piece had already been tagged over. Here, and then gone. It was a shame because the message it represented (no matter how many times your heart gets broken, you can get over it and keep moving onward and upward) would have been nice for more people to get a chance to see in person. But, that's the temporary nature of street art and what the artists themselves, accept. And, especially in the case of Banksy, a very controversial character in the eyes of so many NYC-based graffiti writers, his work was going to be destroyed as quickly as possible. Why?

Well, the resentment is high on the part of writers who have been tagging and throwing on the streets for decades, with the sole purpose of just being 'street.' Not to be 'gallery' or a 'sell-out.' They consider Banksy a sell-out and want to destroy his work to show their disrespect. This extra element intensified the hunt because, not only did I have to try to navigate the streets, train routes, bus schedules, and various maps, I now had to do it quickly in order to beat the bombers.

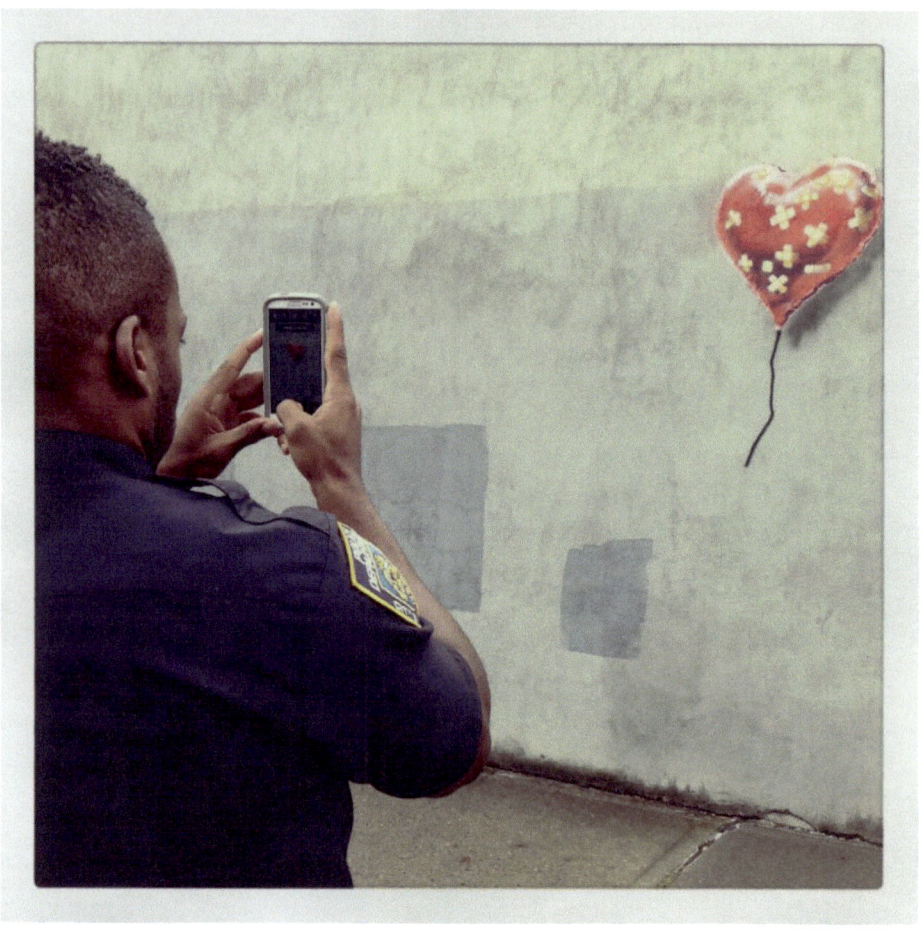

The perfect picture of the NYPD officer snapping a pic of Banksy's 'vandalism.'

A few days after this, Banksy's official Pest Control Office team emailed me requesting permission to use this image on their official NYC Residency website. Of course! I was the only person outside of his team to have their photo on his website. It felt like really being a part of this whole experiment, even if in such a small way.
This was also around the time that I began to realize that the other people on the hunt were actually pretty cool. I began getting tweets from people who seemed even more excited than me that my photo was on Banksy's site. And this gesture from Banksy was just the beginning of what we would see as his way of including people,

involving them, and allowing them to prosper because of him, if they wished.

8 DAY 8, OCTOBER 8^(TH): THE DOOR

"I have a theory that you can make any sentence seem profound by writing the name of a dead philosopher at the end of it." – Plato

This was the quote that Banksy wrote on the door that was in this doorway:

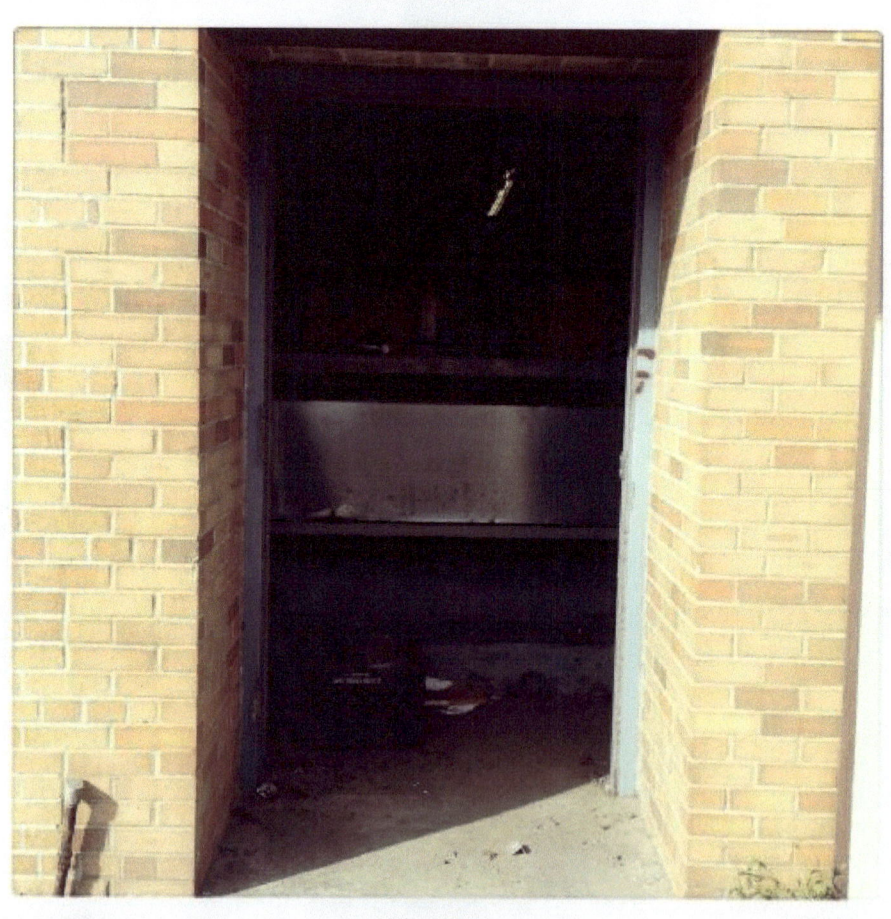

Needless to say, this was a disappointing day. Continuing an unfamiliarity with Brooklyn train and bus routes, I found myself turned around all day. I walked for miles under train tracks in unknown areas that I am fairly certain would have yielded great deals on crack, if the necessity ever arose. I even left Manhattan for Brooklyn before an exact street location was even posted on the Banksy Instagram feed. For that reason, I found myself going one way, getting a wrong street address, hopping off of a train in the wrong place, getting another lead on the location, hopping on a different train, finding out after I regained cellular service on my iPAD, that I was in the wrong area again. Nightmare. It was a race against the clock, as well, because I knew it was a matter of time before the piece got tagged and/or the door got unhinged. At 3:15pm, the door went down. At 3:32pm, I arrived. All I got to see was an empty void which used to hold the door.

But, there's something to say for Banksy's intentions. He chose to write on the door of a machinist shop in a remote area of Brooklyn. He had to know that the shop's owner stood to make a considerable profit off of this piece. The rumor when I arrived, was that the guy had already been offered $40,000 for it, so was hurriedly unhinging it before anyone came up to destroy it. It was a long walk - train to train - walk home that night.

9 DAY 9, OCTOBER 9TH: CRAZYHORSE ATTACK

One of my easiest days. I had already planned to have breakfast at a diner in the Lower East Side on this morning, so I was unknowingly, in the vicinity of this day's piece. After breakfast, as it was still too early to get an announcement on the Instagram feed, I walked around the area documenting the best of NYC's street art already out there. Eventually, Instagram cried out "Ludlow Street" and my heart jumped! I knew I was close, but taking no chances, I hailed a taxi, and for $5, made it to Ludlow. It was 1030am and already a sizeable crowd was gathered in front of a tall fence. Here's the piece:

For many of Banksy's pieces during the month, he would provide a 1-800 number that people could call and listen to the accompanying audio. This is what came from this day's audio: it was from the actual audio recording of an attack on Iraqi civilians in Baghdad in 2007 that was given by Chelsea Manning to Wikileaks. The call signs of the two Apache helicopters involved in the attack were "Crazyhorse 1/8" and "Crazyhorse 1/9." At least 12 people were killed in the attack, including two journalists working for Reuters, and 2 children were wounded. One of the American soldiers involved can be heard remarking, "Well, it's their fault for bringing kids into a battle."

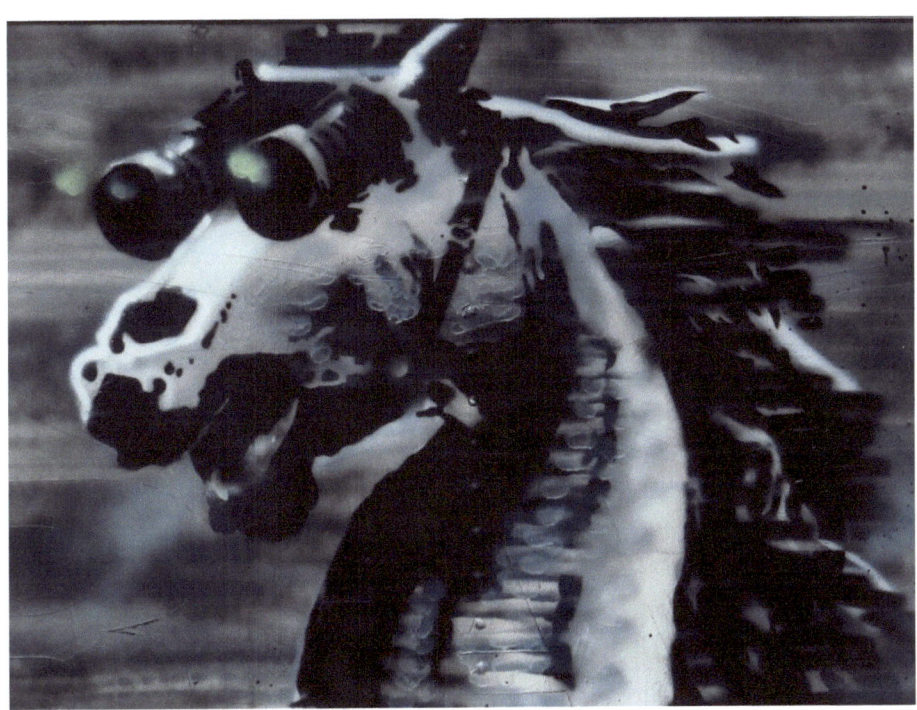

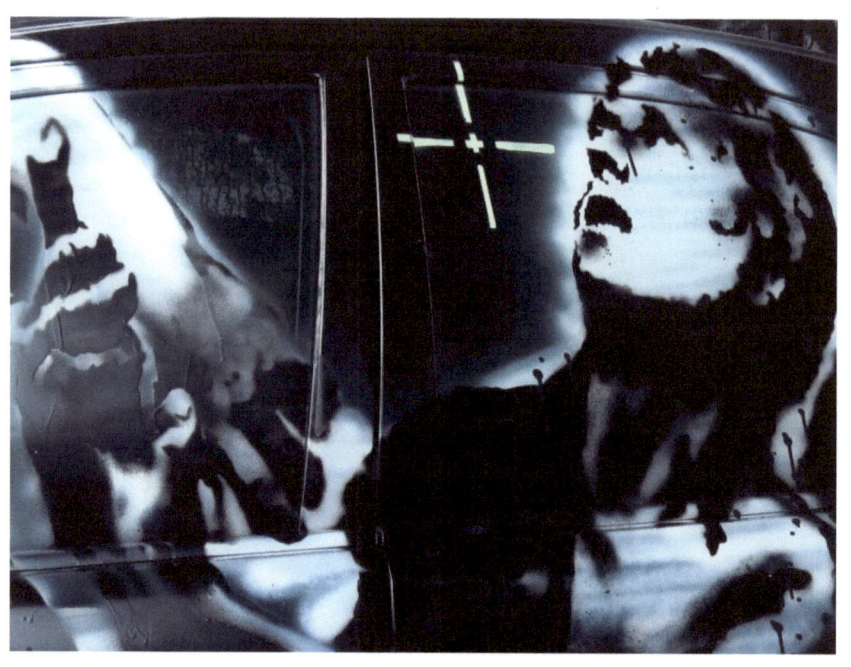
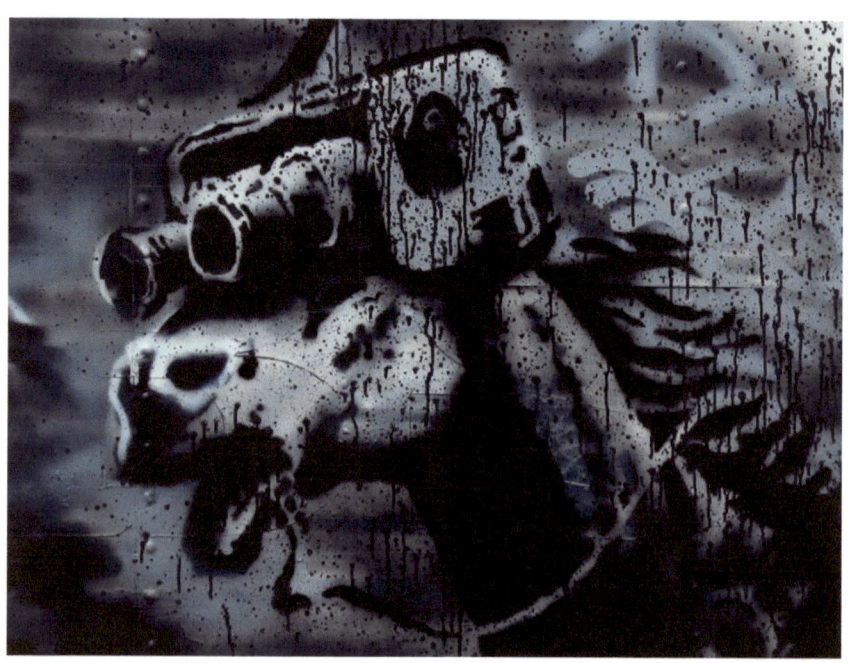

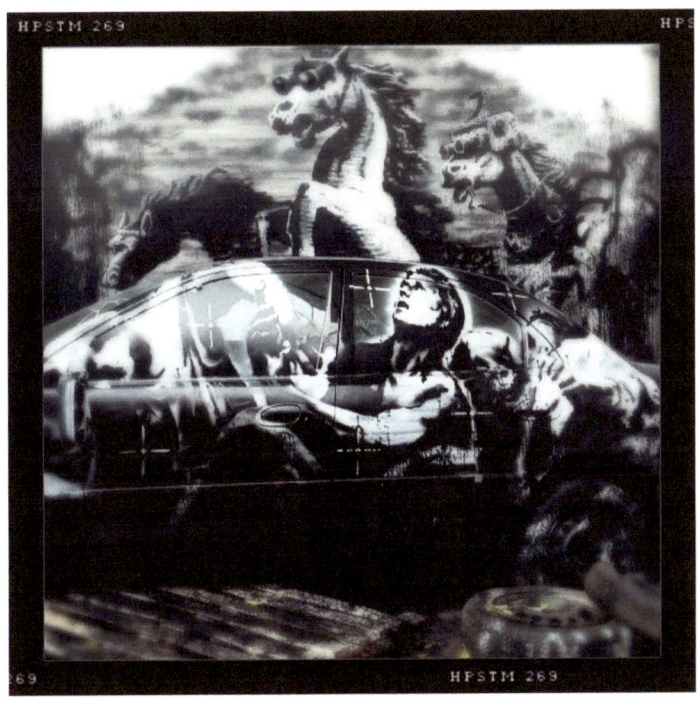

and the fence obviously didn't keep people from getting in to take a closer look:

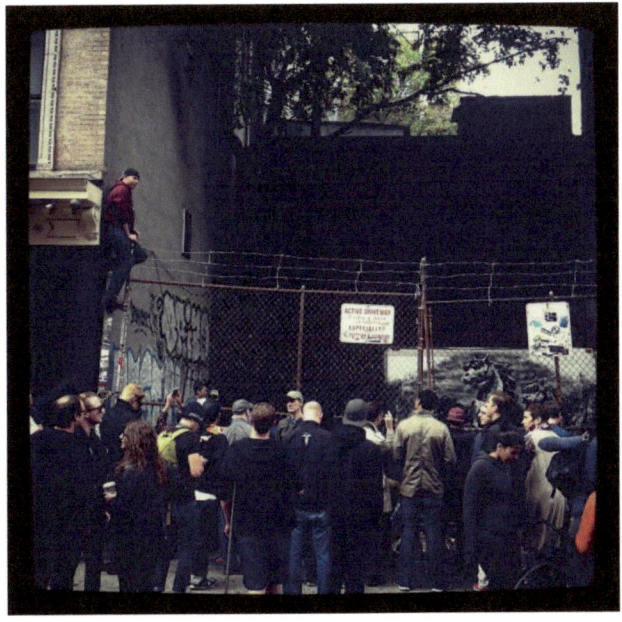

10 DAY 10, OCTOBER 10TH: THE BEAVER

Turns out, this day's site in East New York was just a little too dangerous and sketchy to be hanging around for any period of time. I was going to go, but I kept getting reports from trusted sources that it would be a wasted trip. For the first time in Banksy's NYC residency, there were actually two guys (not associated with him) that were covering the beaver with cardboard and making people pay to snap pictures! As much as $20! From what I hear, in that neighborhood, you don't argue with such an arrangement. I would have been furious, though, so it's good that I didn't go. Reports also came out that two guys (maybe the same fellows) unsuccessfully tried to hammer the beaver out of the wall, did some damage to it, but finally gave up when they realized they just didn't have the proper tools. A friend did go, and here is a shot he got before the guys covered the beaver back up with cardboard:

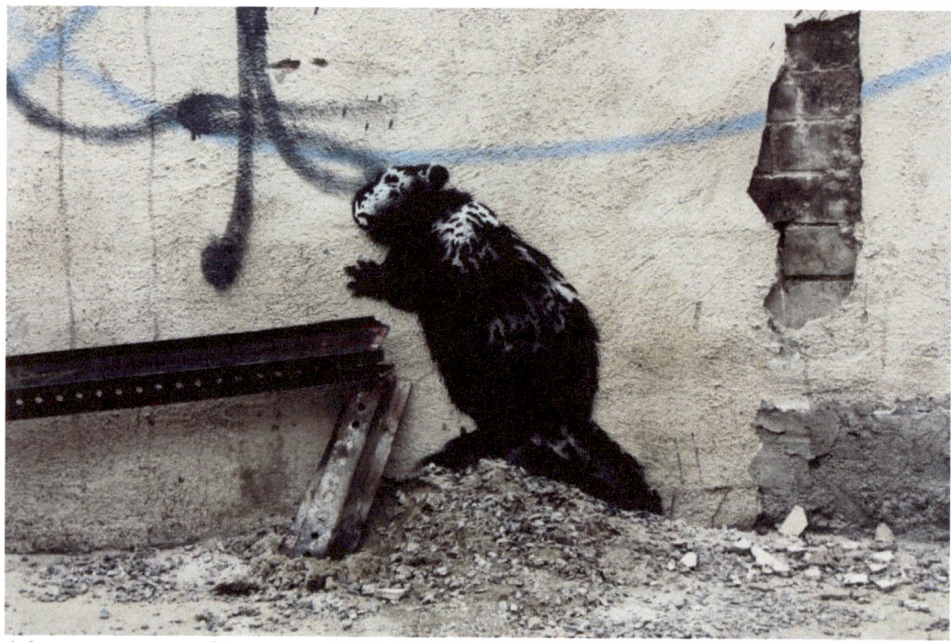

(photo courtesy of Jermaine K. Bell)

11 DAY 11, OCTOBER 11TH: SIRENS OF THE LAMBS

This is another piece I didn't get to document. And at one point apparently, I was only one street away from it. It was a moving truck installation of a 'slaughterhouse.' It was filled with stuffed animals and a recording played of the animals crying, crammed into the back of the truck. It began its tour in the Meatpacking District. I don't know what happened that day, but my foot was so severely injured, that I couldn't walk at all. It was the worst cramp I had ever experienced and I was pretty much out of commission to be able to chase the truck. Slightly disappointing, but again, I prefer Banksy's stencil work.

12 DAY 12, OCTOBER 12TH: CONCRETE CONFESSIONAL

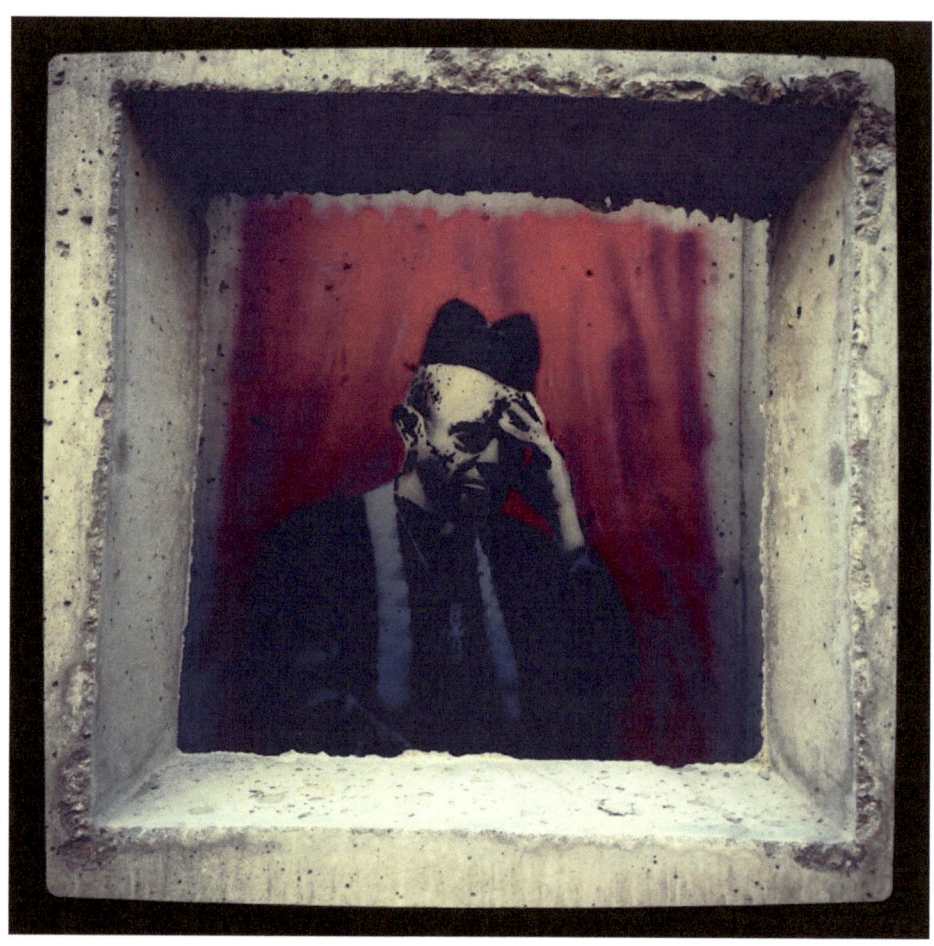

This was another day that I hailed a taxi to get to the site as quickly as possible. This one was on Cooper Street in the East Village. It makes you wonder again how much Banksy knew about the current situation with the Cooper Union School.

from freecooperunion.com:

"With the start of the 2011-12 Academic year, Cooper Union's new

President Jamshed Bharucha announced that in the shadow of unmanageable deficits, the Cooper Union must place "tuition on the table," and consider charging Cooper Union students to attend the school. For the past century Cooper Union has existed as a meritocracy: awarding a full scholarship to all students. Turning Cooper Union into a tuition based school is a profound departure from the established principles of the school and would completely alter the character of the institution.

The Free Cooper Union initiative represents the members of the Cooper Union community who wish to support the Cooper Union's strong and unique identity as a tuition free undergraduate school for the study of architecture, art and engineering.

We alumni, students, faculty, charitable individuals and institutions pledge our full financial support to the Cooper Union as soon as the administration states publicly and unequivocally that Cooper Union's undergraduate schools of architecture, art and engineering will remain completely tuition free.

The Cooper Union exists as a unique and revolutionary model of education and an ideal and example to institutions of higher learning the world over.

We believe in Peter Cooper's original mission. We believe in sustaining this mission for all future generations. This mission is clearly expressed in Cooper Union's mission statement:

'The College admits undergraduates solely on merit and awards full scholarships to all enrolled students.'"

This piece started as Banksy's Concrete Confessional, but has been re-appropriated by Cooper Union students and an image of the current president has been added.

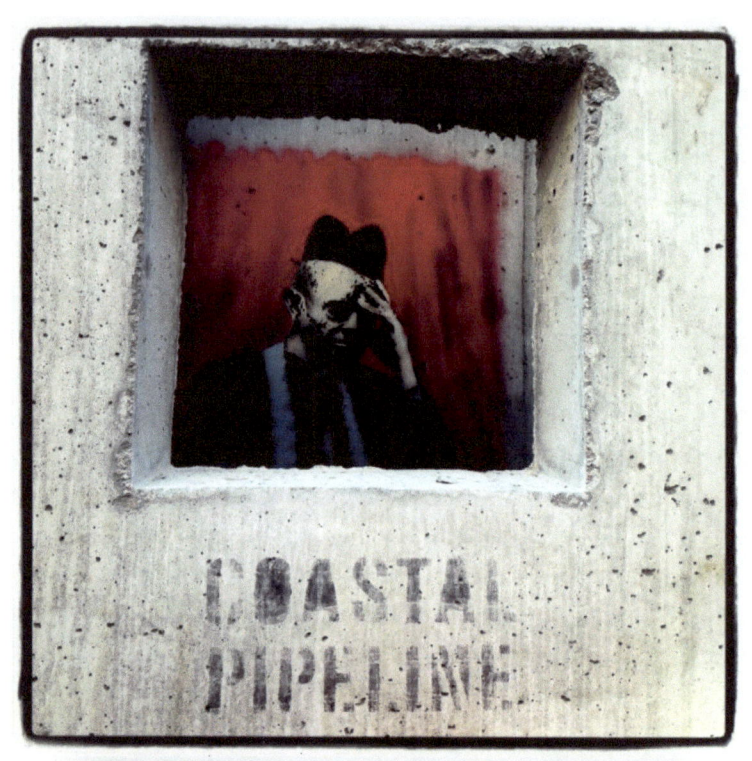
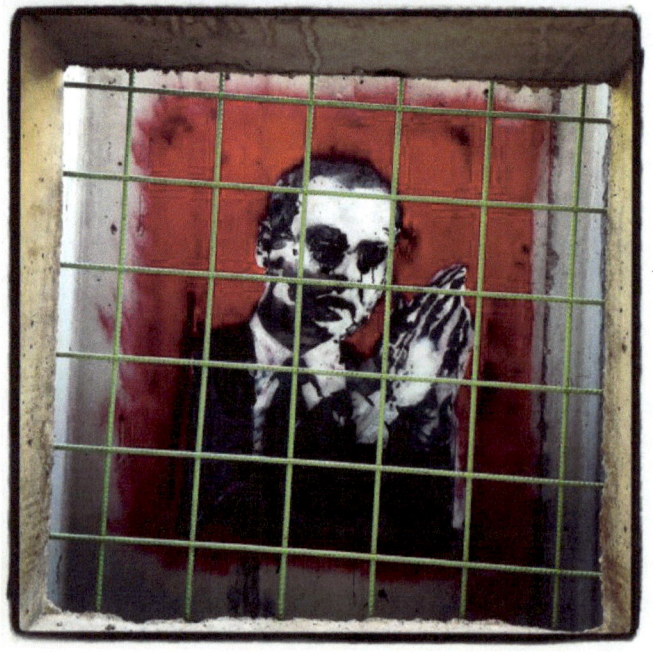

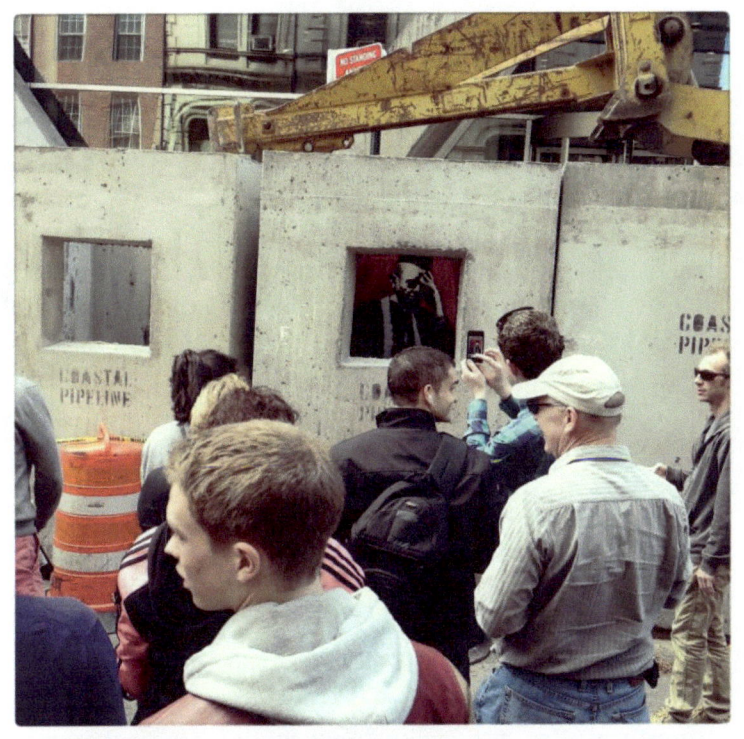

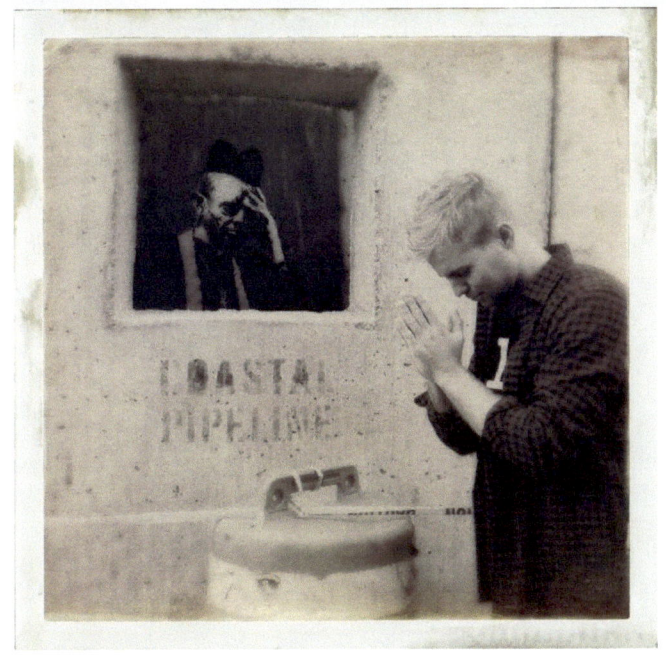

13 DAY 13, OCTOBER 13TH: THE CENTRAL PARK STALL

By far, this was the most difficult and heartbreaking day for me and tons of Banksy fans hanging out in the city. It was also, in my opinion, the most brilliant thing Banksy did the entire residency. He hired out an older gentleman's stall in Central Park and had the man sell original Banksy prints, signed and everything, for $60 a pop. This stunt was obviously not publicized before it happened, so it played out that random people walking in the park that day with no idea who Banksy was, stopped and bought a few. One woman bought two, after haggling for a lower price. The one that got me was the guy from Chicago who bought four saying pretty much, "What the hell? I need to decorate my new apartment walls with something," so he chose four without a care in the world. After the day was over, Banksy posted a video on his site showing exactly how the day transpired.

I know I was gutted. I imagine most people were. The idea that tormented me the most was that I feared that if I had actually been graced with the good fortune to have walked past that stall on that Sunday afternoon, I'm not really sure I would have actually bought one, anyway. First reason is that I travel so much, I can't really carry anything around. And the prints weren't being promoted as Banksy originals, it was just an old man sitting at a stall in Central Park selling 'Banksy-like' pieces. The second reason, which forces me to be really honest with myself, I probably don't even possess the discerning eye to know whether one is an original or not. Which, I believe, was Banksy's point. For two weeks, so many of us had been running around the city, chasing his work, calling ourselves Banksy fans, but when it's sitting right there in front of our noses, we don't even recognize it. Banksy called out the hypocrites with this one.

NOTE A couple of weeks later, some guys set up a stall and publicly acknowledged that they were selling Banksy copies, definitely not orginals. And…they sold out.

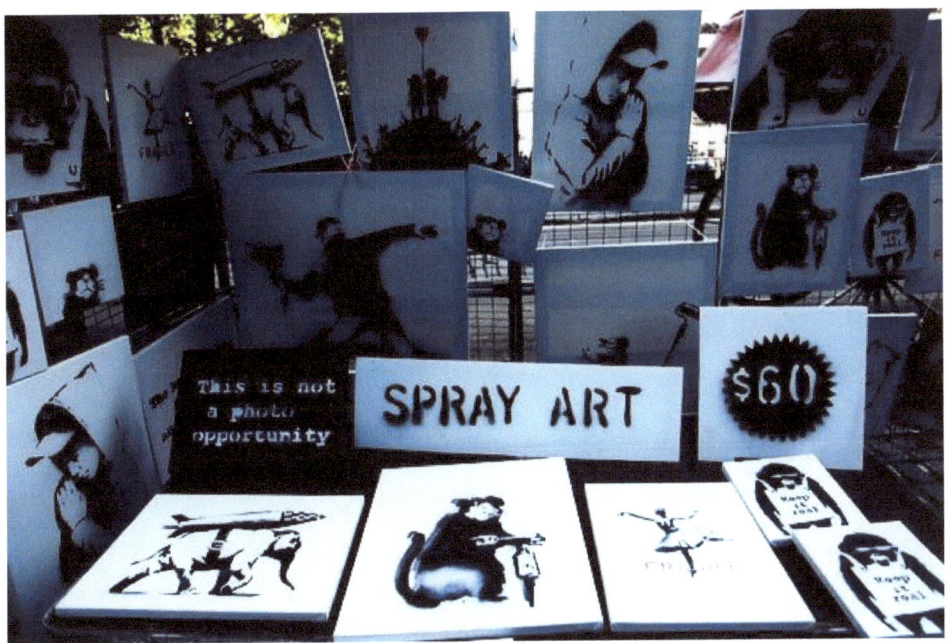
(photo courtesy of Banksy's website)

14 DAY 14, OCTOBER 14TH: WHAT WE DO IN LIFE ECHOES IN ETERNITY

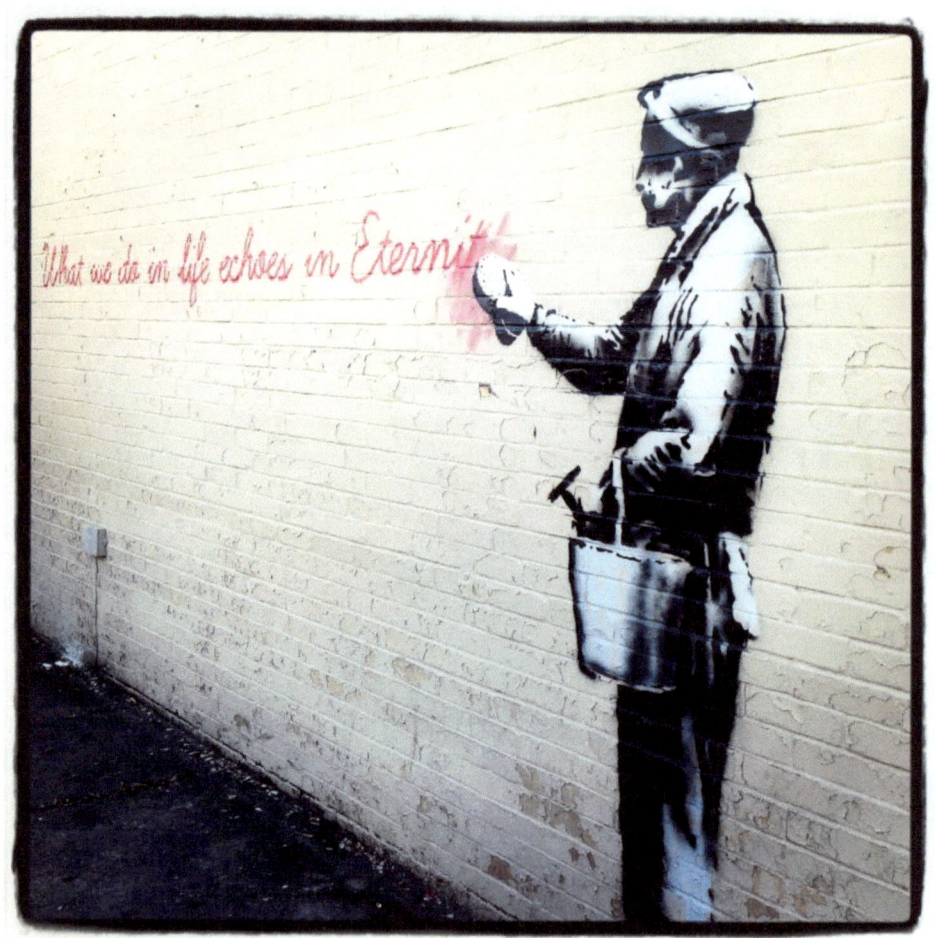

Greenpoint, Brooklyn

This piece uses a quote from the movie, "Gladiator." I definitely think it's directed towards the taggers, bombers, and haters of his residency thus far. You have a guy wiping away the paint, besmirching the image. And the line reads as something quite karmic. Banksy's telling these guys (and all Banksy haters) that their

destructive ways will manifest for eternity. What's in your soul now, will be in your soul forever. And note the irony of wiping away the word "eternity."

Banksy was also taking the piss out of his critics who call him shallow and low-brow. What better way to annoy them than to appropriate a cheesy quote from a hugely popular commercial blockbuster like the "Gladiator?" And then more to the point, in defense of this piece he quoted Kelly Rowland from the X Factor by saying that he would "use this hostility to make him stronger, not weaker." Satire at its finest.

15 DAY 15, OCTOBER 15TH: TWIN TOWERS FLOWER EXPLOSION

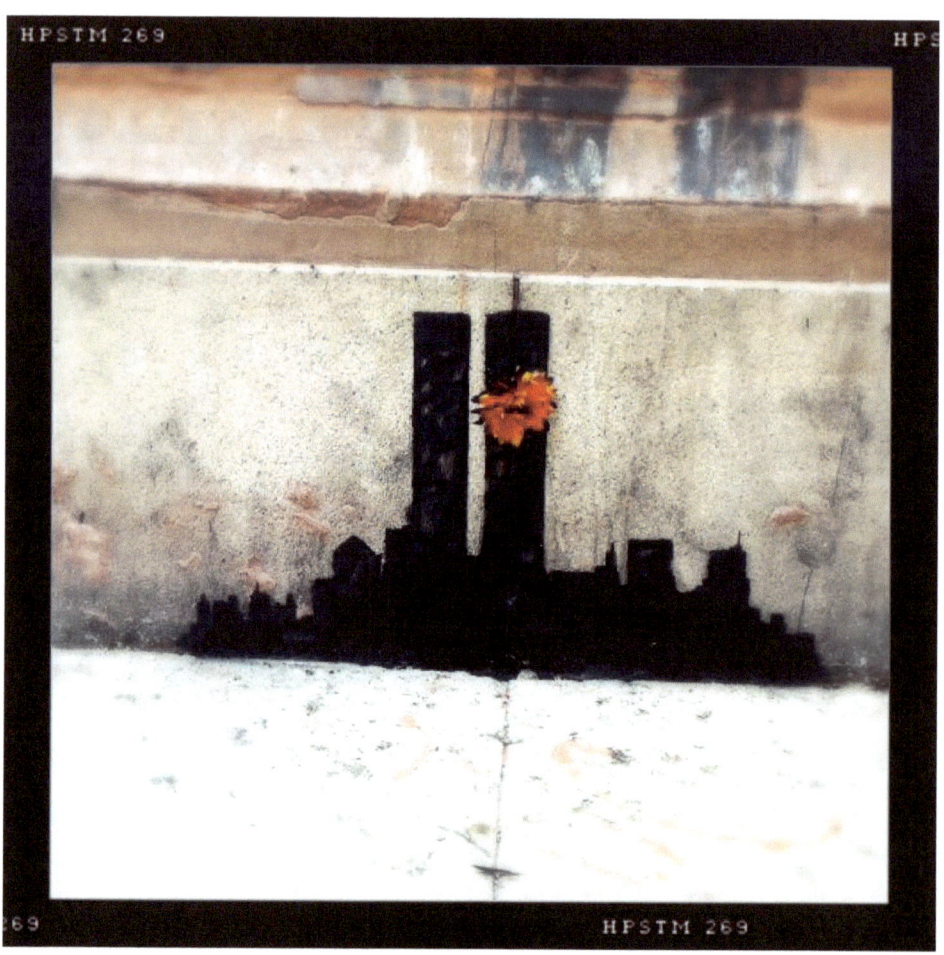

Tribeca.

Here is a stencil of the Twin Towers with what appears to be a chrysanthemum sticking out of it. The flower seems to represent the first explosion on 09/11/01. In some cultures, chrysanthemums represent death and are only used at funerals or for graves.

This was a sentimental move by Banksy and real New Yorkers were less likely to destroy this piece, as it is too important of a symbol for

the city. A really large crowd gathered, and probably the most respectful one at that. There was no pushing or shoving, just quiet reflection.

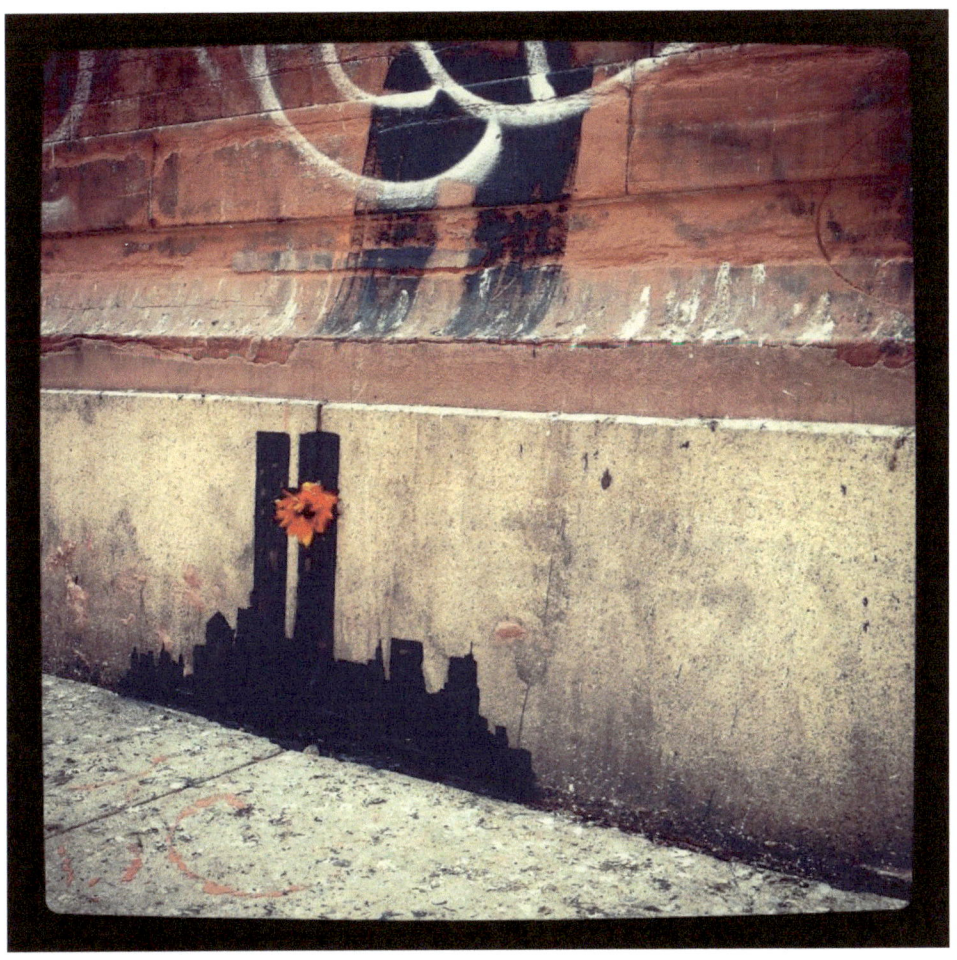

16 DAY 16, OCTOBER 16TH: RONALD McDONALD

For Day 16, Banksy created a fiberglass replica of a sad Ronald McDonald having his shoes shined by a real person outside a McDonalds in the South Bronx. According to <u>Banksy's website</u>, "The sculpture will visit the sidewalk outside a different McDonalds every lunchtime for the next week."

The accompanying audio guide to the piece said "Ronald [is] arguably the most sculpted figure in history after Christ." The sculpture is "a critique of the heavy labor required to sustain the polished image of mega-corporation…"

The narrator also notes that the face is actually of the Greek God Hermes.

In some myths Hermes is a trickster, a kind of con man, and outwits other gods for his own satisfaction or for the sake of humankind.

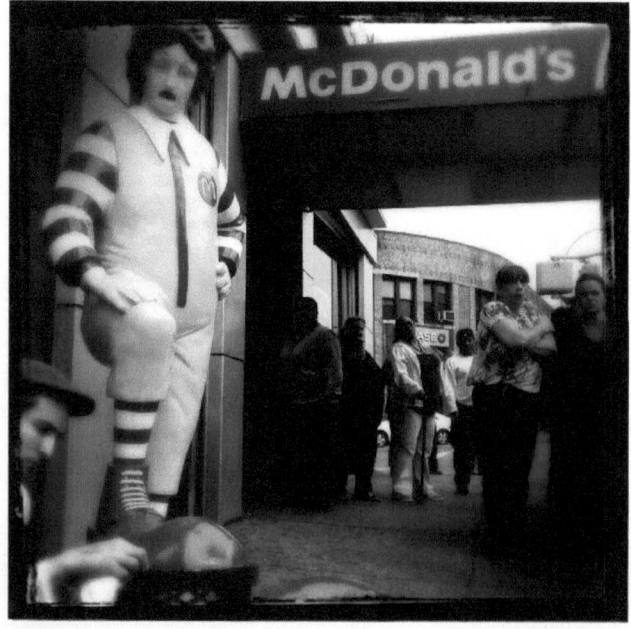

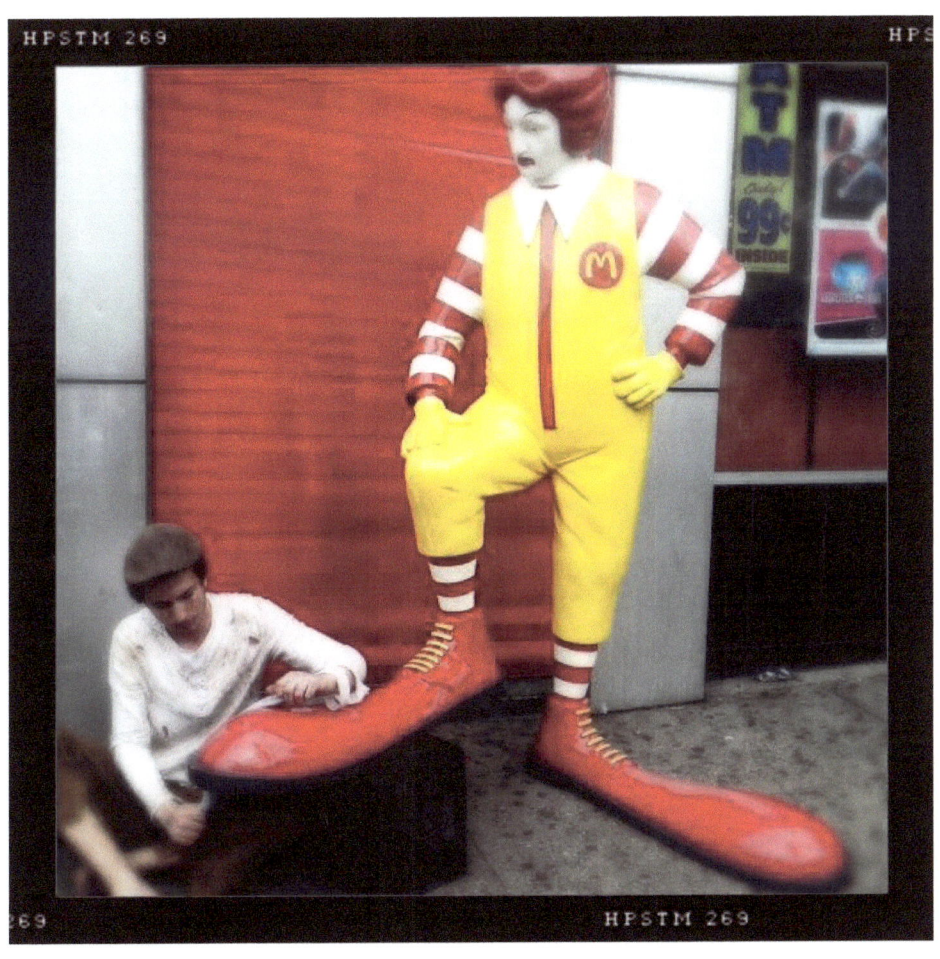

17 DAY 17, OCTOBER 17TH: GEISHA SILHOUETTES

I actually didn't make it here until the next morning, the 18th, because there was so much drama surrounding this one since it was announced. On the 17th, I was lost in some other area of the city when this piece came up on Banksy's Instagram feed. I was trying to make it there, but along the way, I was getting messages that it had already been defaced, so I turned around; I just didn't have the energy. When I got home, I found out that it had been restored pretty nicely by a group of Banksy fans, so I decided to go back the next morning. I don't know what this piece represents. It very well may have no meaning at all other than two geisha silhouettes standing on a bridge. Which, would be perfect.

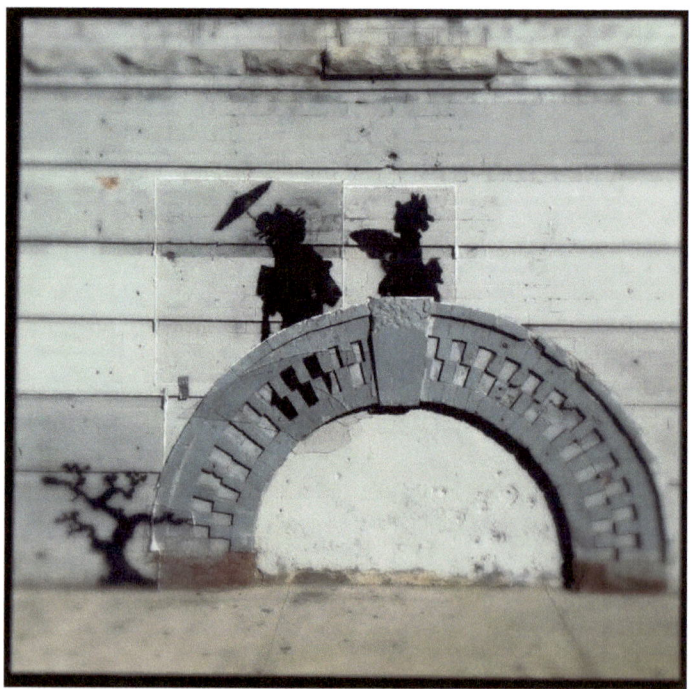

Notice the plexi-glass that has been placed on top of it to protect it. And also, you can see the black smudging around the one on the left. Fans cleaned it up respectably, you'd have to say. (photo 18/10/13)

18 DAY 18, OCTOBER 18TH: COLLABORATION WITH OS GEMEOS

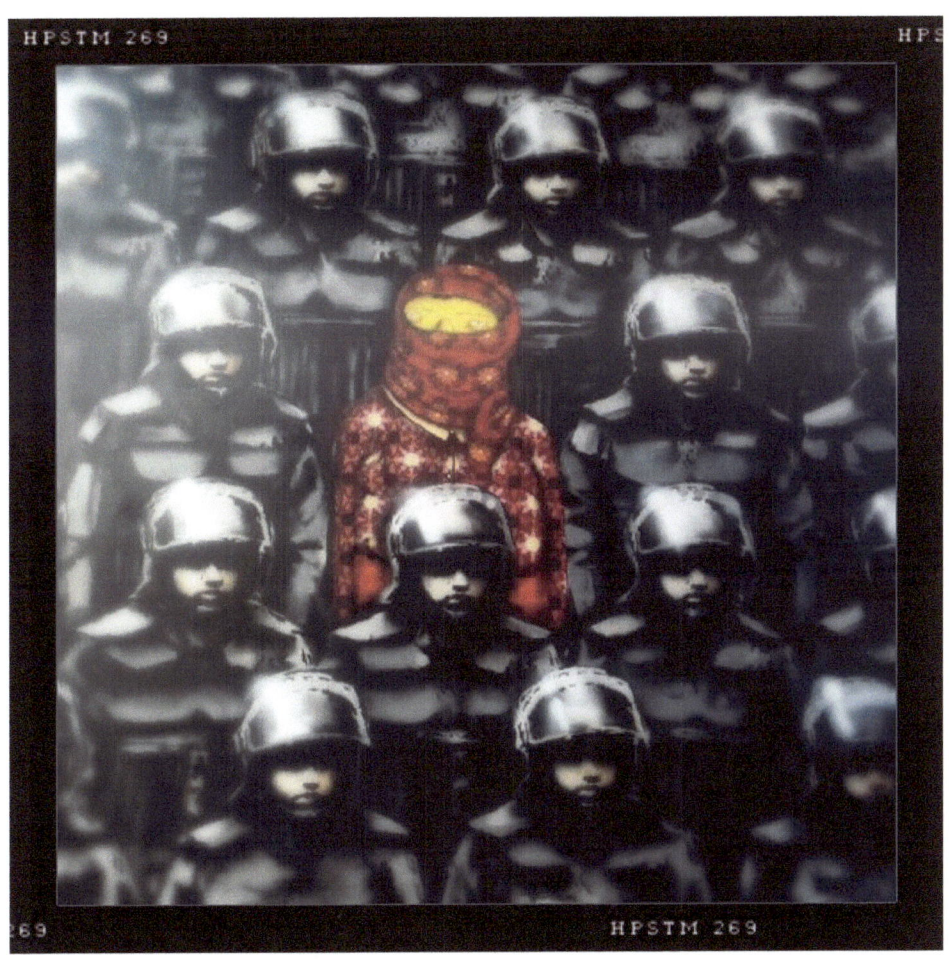

On this day, Banksy converted an outdoor lot in the Chelsea design district into an open air art gallery, complete with a security guard and water cooler. Standing at a gate like herded cattle, clumps of people were let in to get a closer look at the paintings that were hanging from an iron rafter.

The paintings had actually already been featured on two covers of The Village Voice, when the magazine did an interview earlier in the

month with Banksy. Interesting collaboration, for sure. Juxtaposing the iconic styles of Os Gemeos (Brazilian twin brothers) and Banksy…their yellow people with Banksy's riot police. Gotta love it.

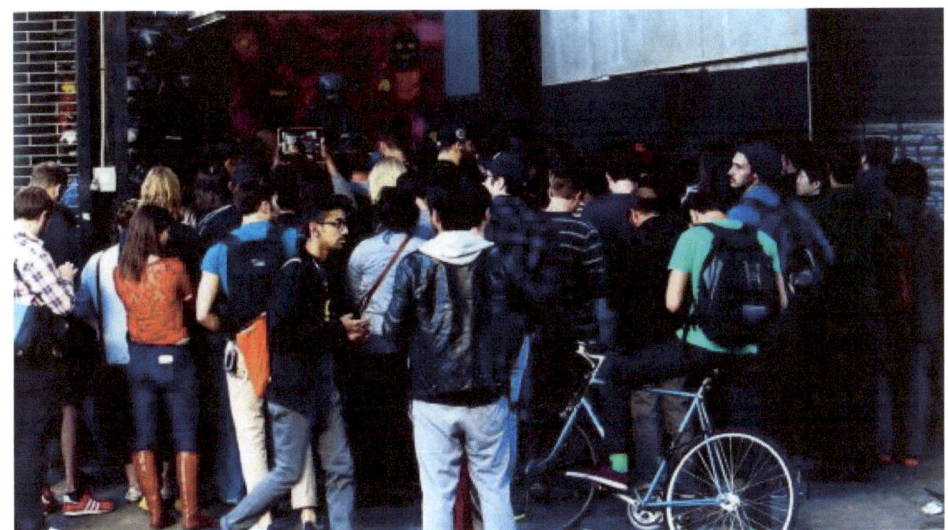

A horde waiting to enter…

19 DAY 19, OCTOBER 19TH: ANTHILL

Banksy posted a video on this day saying that what was occurring was happening in Staten Island. Basically, it was just a video with an army of ants speedily dissipating to reveal what appears to be a vagina shaped by a crack in a wall. Weird. I thought it was obvious that there was no actual relic to this performance, so I watched the video and that was that. But, others when hunting in Staten Island. Guess what? They didn't find anything, but they did get to know Staten Island just a little bit better.

20 DAY 20, OCTOBER 20^(TH): HAMMER BOY

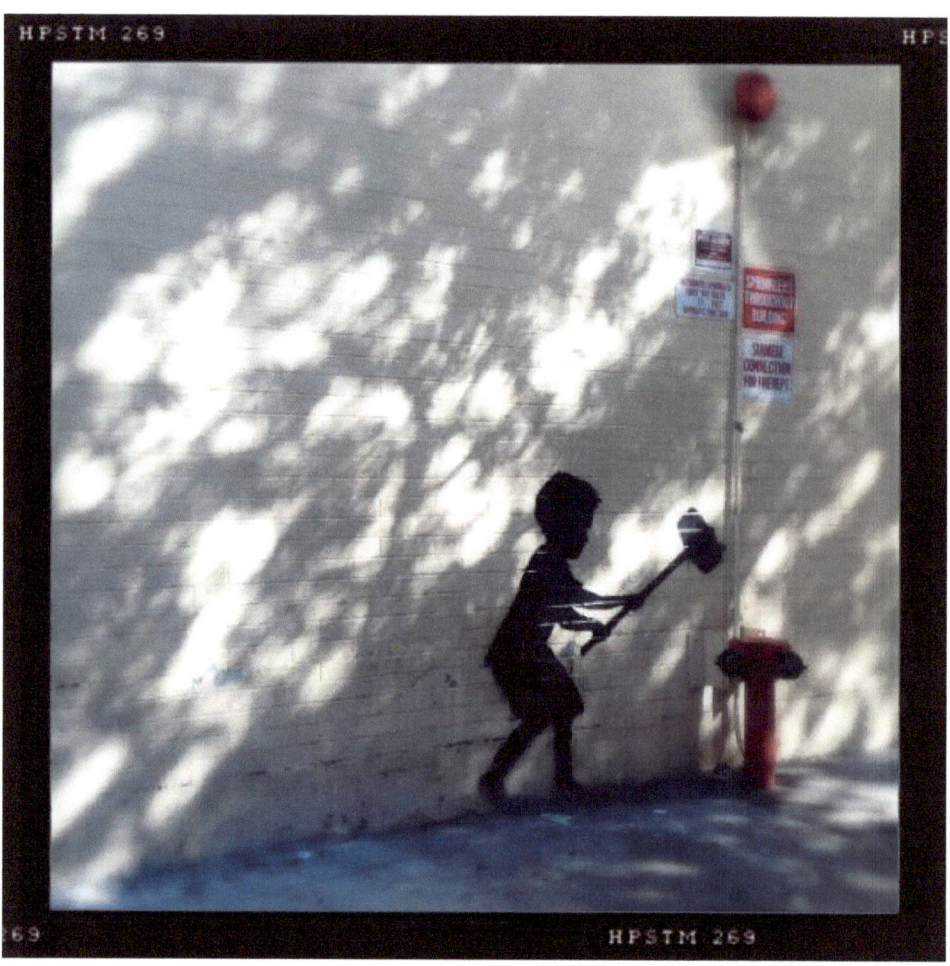

This one was featured in the Upper West Side on a beautiful Sunday afternoon. Lots of people came out to see what all of the Banksy fuss was about. Just a cleverly positioned stencil of a boy with a hammer next to a fire hydrant, making it look like he was playing a carnival game.

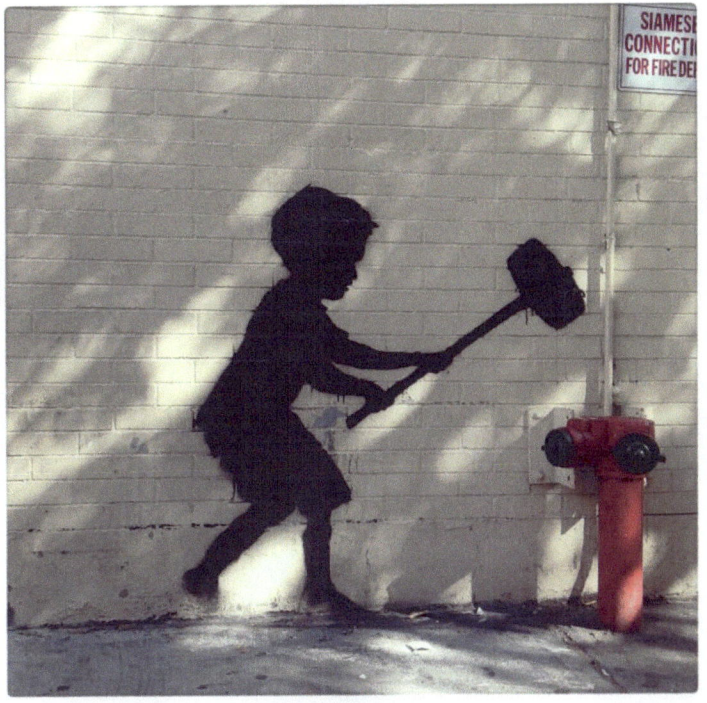

more police interest:

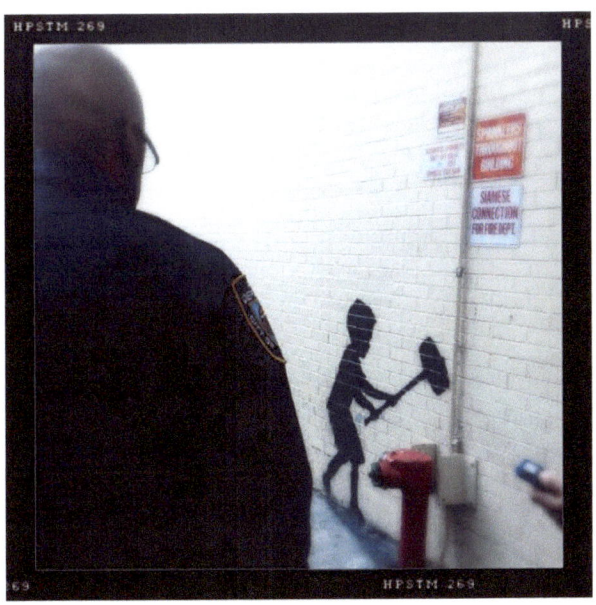

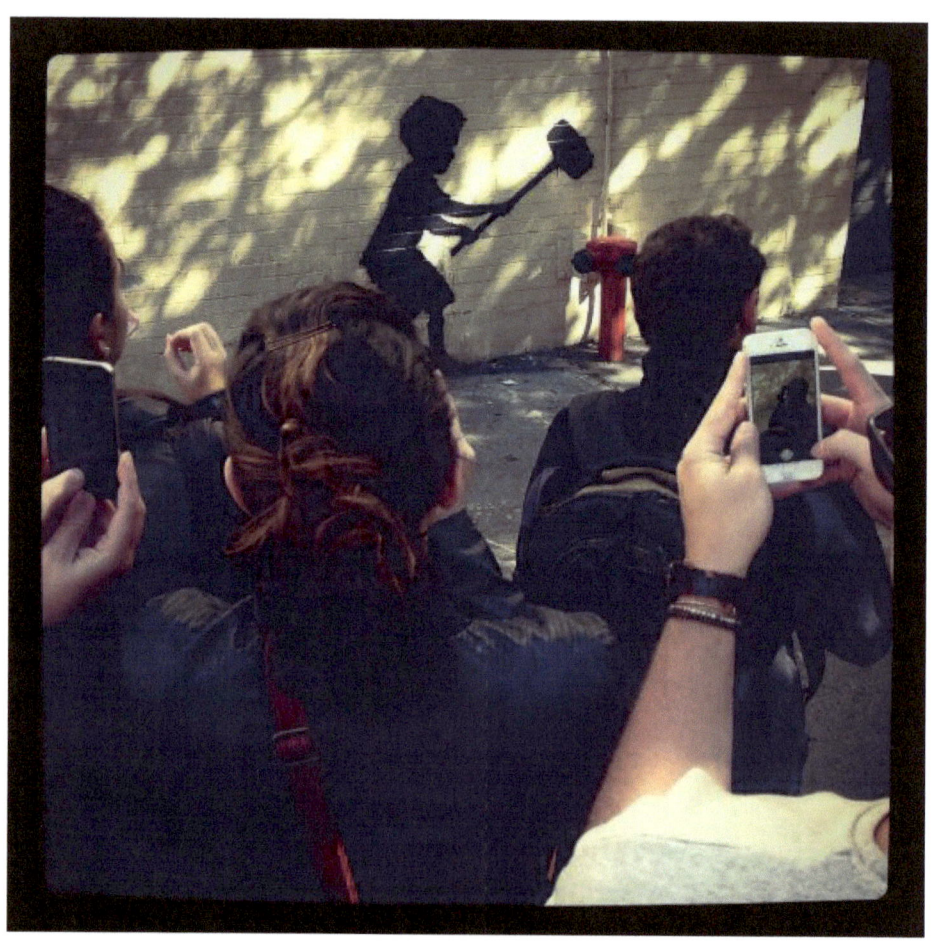

This one brought one of the biggest crowds I had seen up to that point in the residency.

21 DAY 21, OCTOBER 21ST: GHETTO 4 LIFE

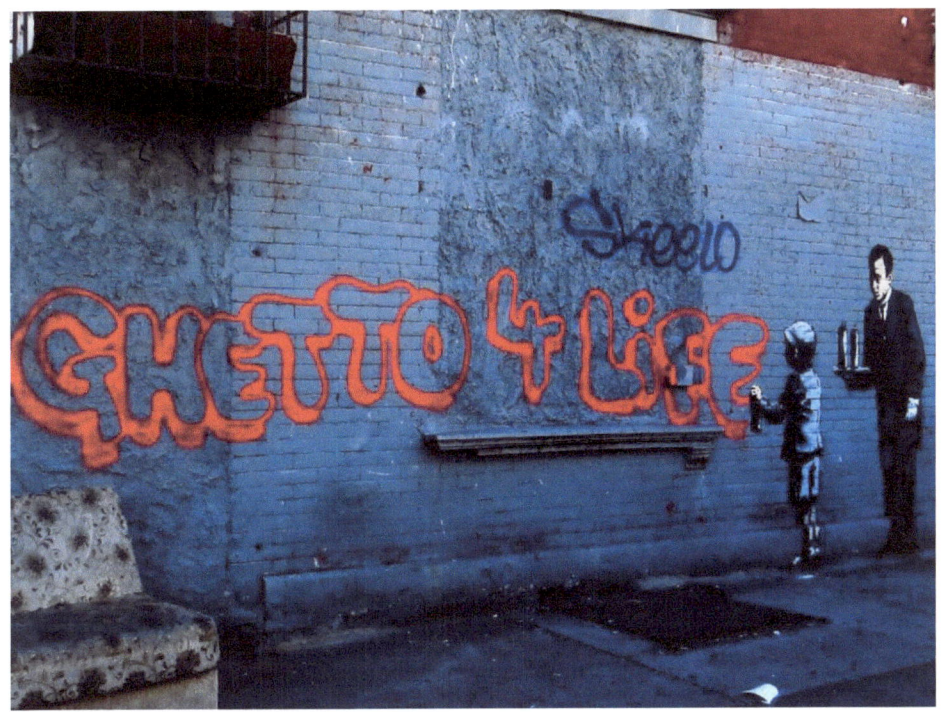

This one took a lot of nerve. Painting "Ghetto 4 Life" in a low-income neighborhood in the Bronx. Even more to the point, having an affluent white boy flanked by his butler, doing the spraying.

This is well thought-out from the beginning. Banksy even writes it in childlike bubble-style, to highlight the child's inexperience, showing also, how much he doesn't know about what he's actually writing.

Bronx residents were in an uproar about this, saying that it enforced the deeply-ingrained stereotype that has been directed towards the Bronx since the 1970's; low-class, uneducated, and criminal in nature.

The fact that they can't see the joke, the audacity, I don't know…and

then it was pointed out that in America, the term 'ghetto' has a negative connotation, but maybe a supposedly white, English street artist doesn't know that. Oh, he knows it.

22 DAY 22, OCTOBER 22^(ND):
EVERYTHING BUT THE KITCHEN SPHINX

This one was in the most remote spot of the whole month, Willets Point in Queens. I didn't bother to go because, again, it's not a stencil. It's a sphinx. And I've seen the real one.

Seriously, though, there was definitely some thought about the placement of this one (as really, all of them.) The Mets' Citi Field stadium is in view. It is almost as though the Sphinx represents the brand-new beautiful stadium, and like the real thing, it is surrounded by gutter water, trash. The two environments don't match. Citi Field would like nothing more than to appropriate its surroundings and build modern structures, but alas, the community around it won't concede.

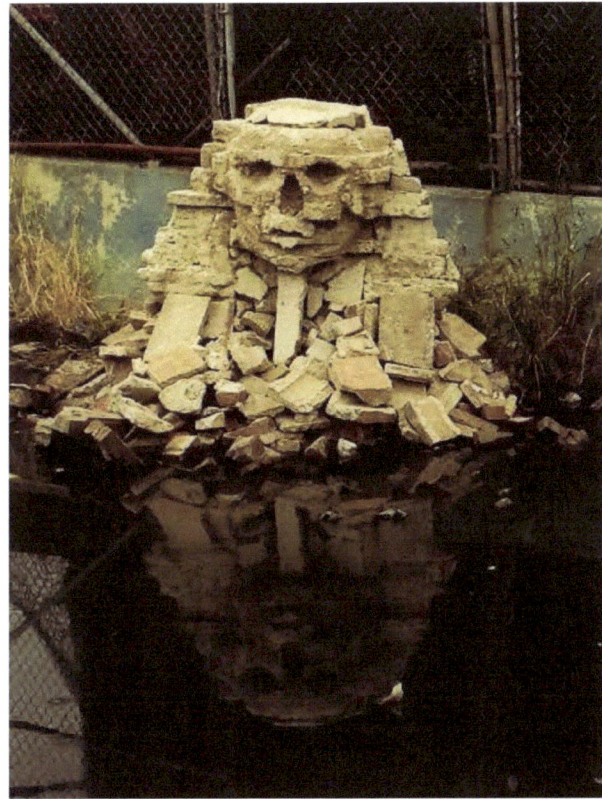

(photo by Emmanuel Laflamme)

23 DAY 23, OCTOBER 23RD: TODAY'S ART CANCELLED DUE TO POLICE ACTIVITY

Woke up on this day with a notice on Banksy's website saying "Today's art cancelled due to police activity." It could either have been true, that police interrupted his latest work and he couldn't get it out there, or more likely, he just took the day off.

I still went out on a NYC graffiti adventure anyway, and strangely enough, I found this posted outside of a subway station in the East Village on Houston Street:

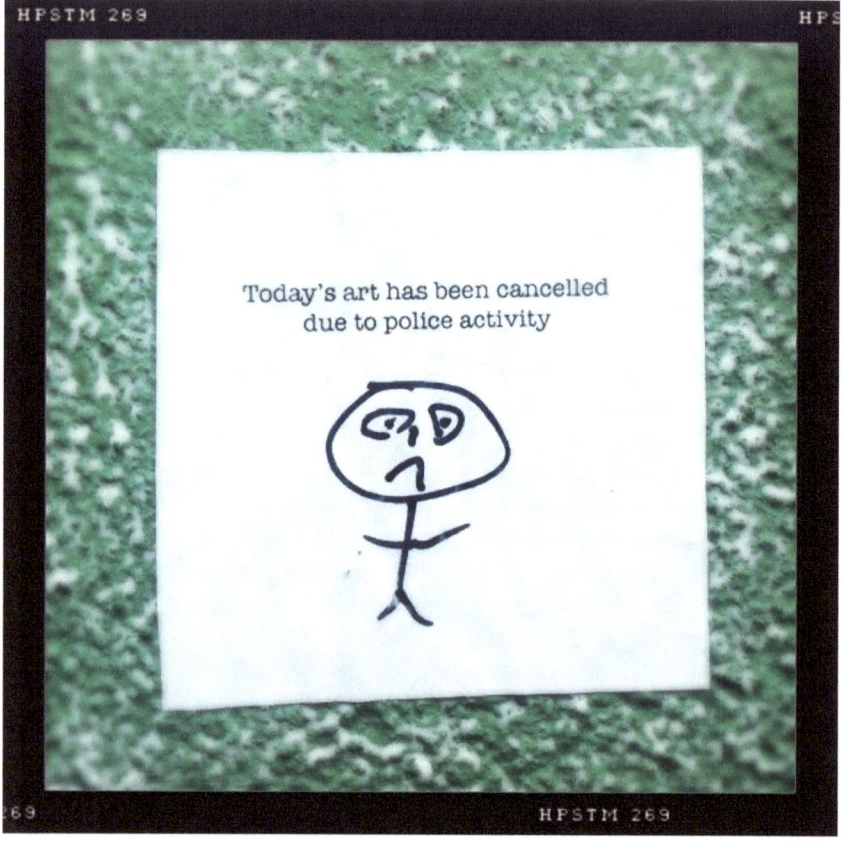

24 DAY 24, OCTOBER 24TH: WAITING IN VAIN

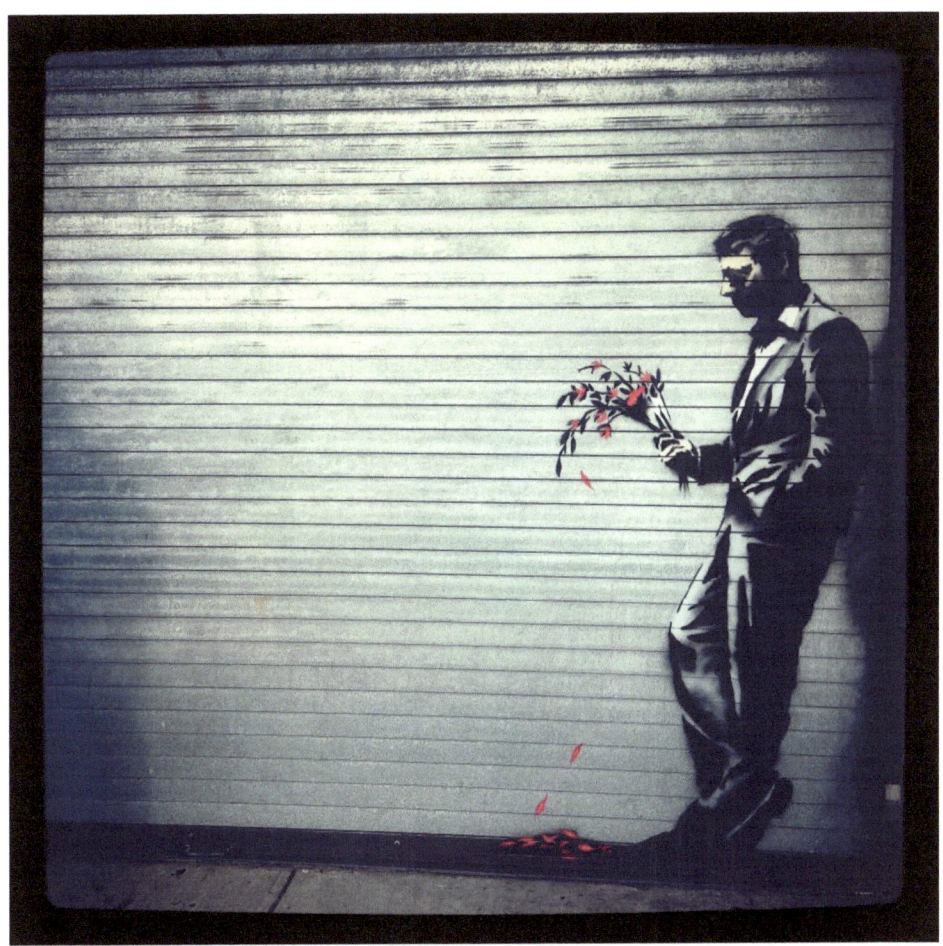

This is one of my favorite pieces. Banksy painted it on the front sliding gate of Larry Flynt's Hustler Club. A sweet reminder to the men who love in the abstract; that image you were admiring and throwing $1 bills at all night, and who smiled longingly at you and played right along…she's not coming out the front door in the morning.

This was also the toughest day crowd-wise. Worst vibe of the month, by far. It made you not want to stay there too long because people

were pushy and tense. Flynt hired a security team. They were nice enough guys, but they acted like they were guarding the Hope diamond. In retrospect, it was all a bit ridiculous. And I was more ridiculous than most.

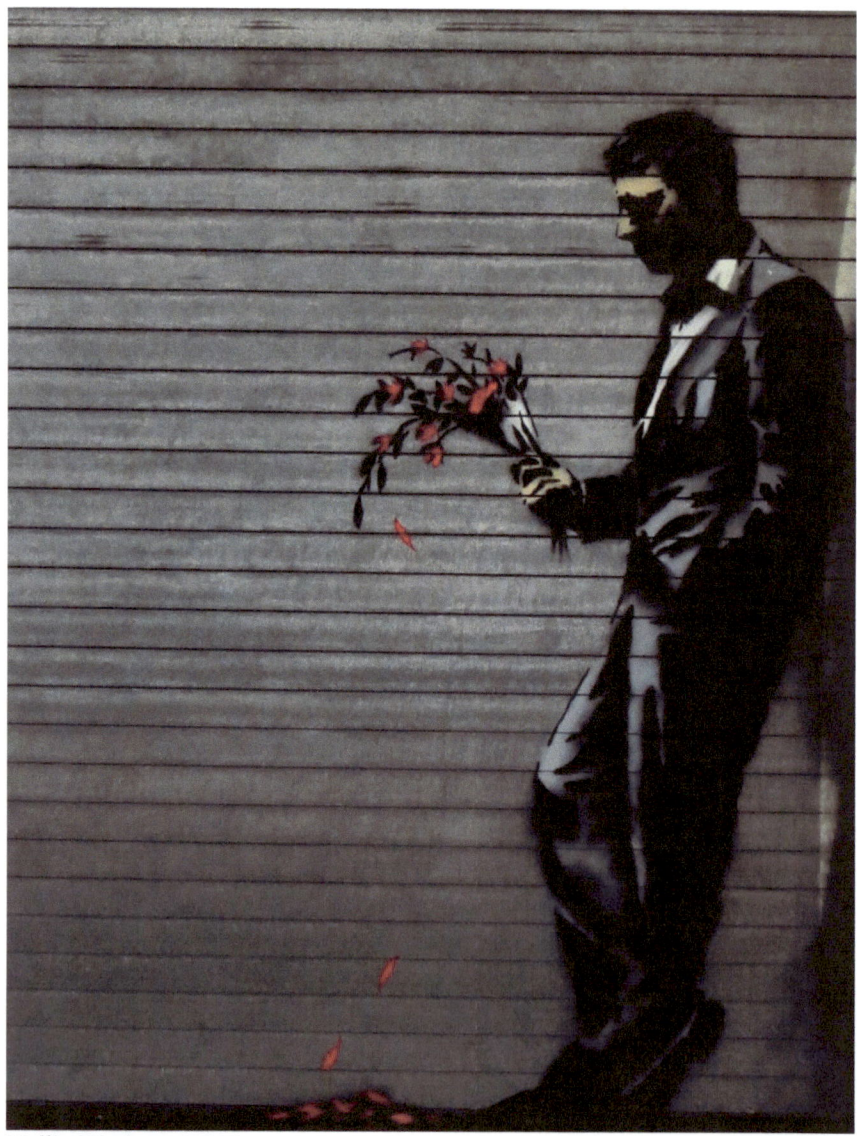

Hell's Kitchen, NYC.

25 DAY 25, OCTOBER 25TH:
REAPER

I didn't make it to this one, either. A YouTube video was posted showing it. It was in the Bowery and it was at night and I knew I wouldn't be able to get a good shot of it with my camera. Banksy basically set up a mechanical reaper in a bumper car and had it going round in circles while Blue Oyster Cult's classic song ("Don't Fear) the Reaper" played on a loop in the background. I think the symbolism of the reaper is enough, but if you want to go into it further and listen to what the song is about, it's about eternal love and the inevitability of death. Surprise, surprise.

26 DAY 26, OCTOBER 26TH:
THE GRUMPIER YOU ARE, THE MORE ASSHOLES YOU MEET

This was an embarrassing one for me. Being a non-New Yorker (as much as I don't want to be), I mistook the address, 1st Avenue or something, as being in Manhattan. I confidently got on the train and headed to where I thought it was. Then I started walking. And walking. And walking. Until I got to the U.N. Building. And I'm still thinking, "Wow, Banksy is brilliant! Doing something around the U.N. today!" After a few hours of finally piecing together that that wasn't the case, I hopped in a taxi and gave the driver the address. He stopped the car and said, "That's in Brooklyn. You don't want me to drive you all the way out there." Damn!

Instead of telling all of my Banksy buddies what happened the next day, I just decided to play it cool and say "I wasn't that impressed. Didn't feel like going all that way." Truth was, I STILL went out to Brooklyn and STILL didn't find it, so...

Banksy wrote this on the back of a delivery truck in Sunset Park: "The grumpier you are, the more assholes you meet..."

27 DAY 27, OCTOBER 27TH:
THIS SITE CONTAINS BLOCKED MESSAGES

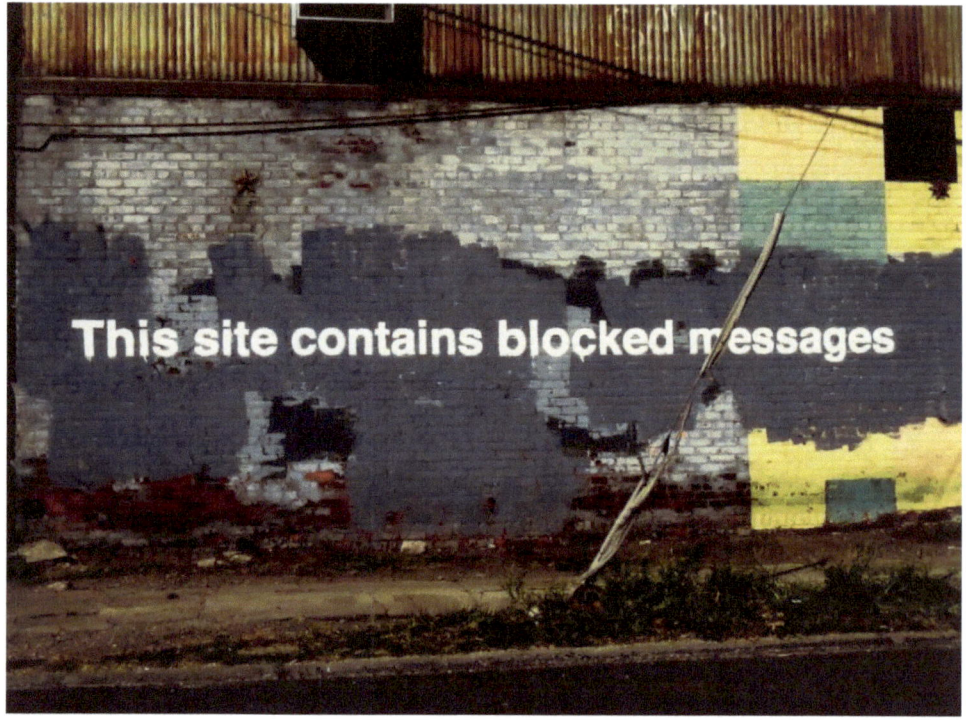

According to Banksy's website on this day, his piece should have been an op-ed column in The New York Times, but the paper wouldn't accept his article. So, he had to take it to the streets (Greenpoint.)

He posted the article in full on his website and it drew some ire. He basically ripped the architectural design of the new World Trade Center, calling it "vanilla," something they might build in Canada. And it goes on.

A risky move, to say the least, as everything about September 11th, 2001, is a sensitive issue to New Yorkers. So, to present a lengthy essay on how ugly and weak their new WTC tower is…well, it didn't bode well. But, people read it. And people came to Greenpoint.

28 DAY 28, OCTOBER 28TH: ROBOT WRITER

Coney Island. I love this one! And even though it was a long train ride to the site, it was easy enough, and it was pleasant enough.

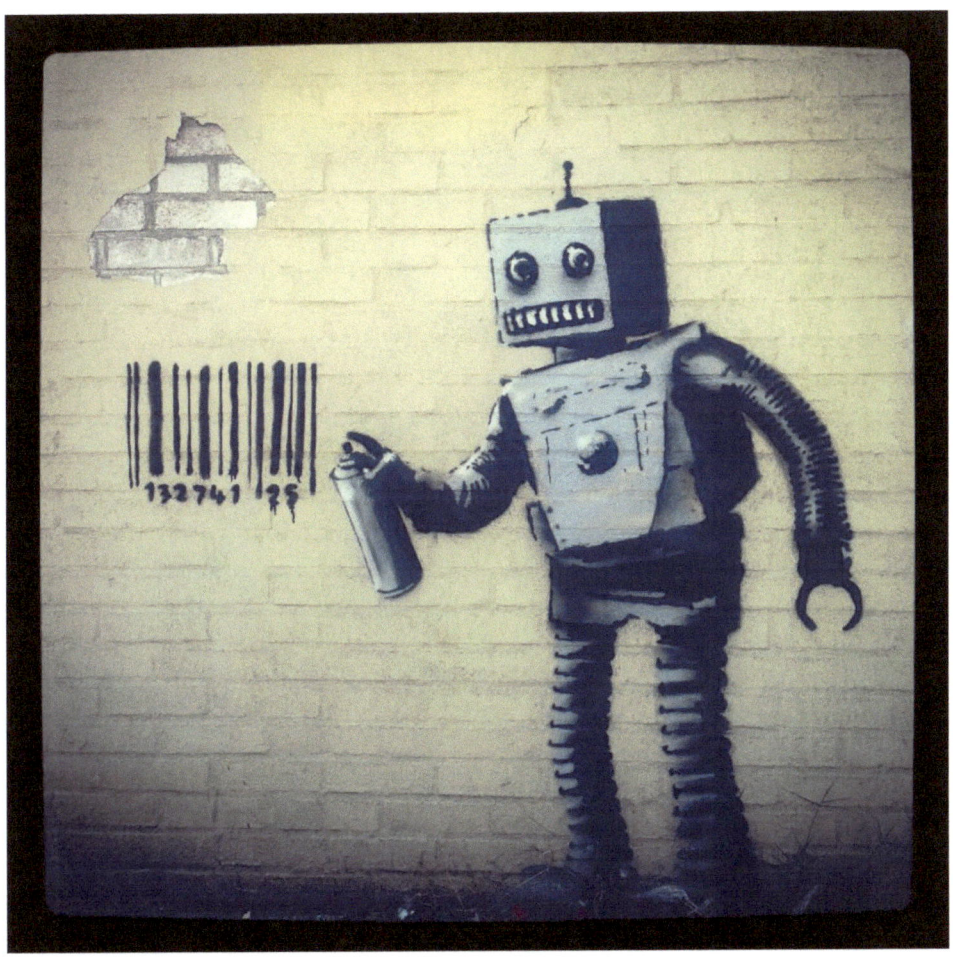

'Old Skool' Robot! Remember when robots used to look like this? Looks like he just got busted with a can of spray paint after painting a barcode on the wall. But, what are you going to do? He's a robot! Rumors were swirling that this code was related to the human genetic code, but I couldn't find proof of that anywhere. It would make

sense, though, and it's something he would think of.

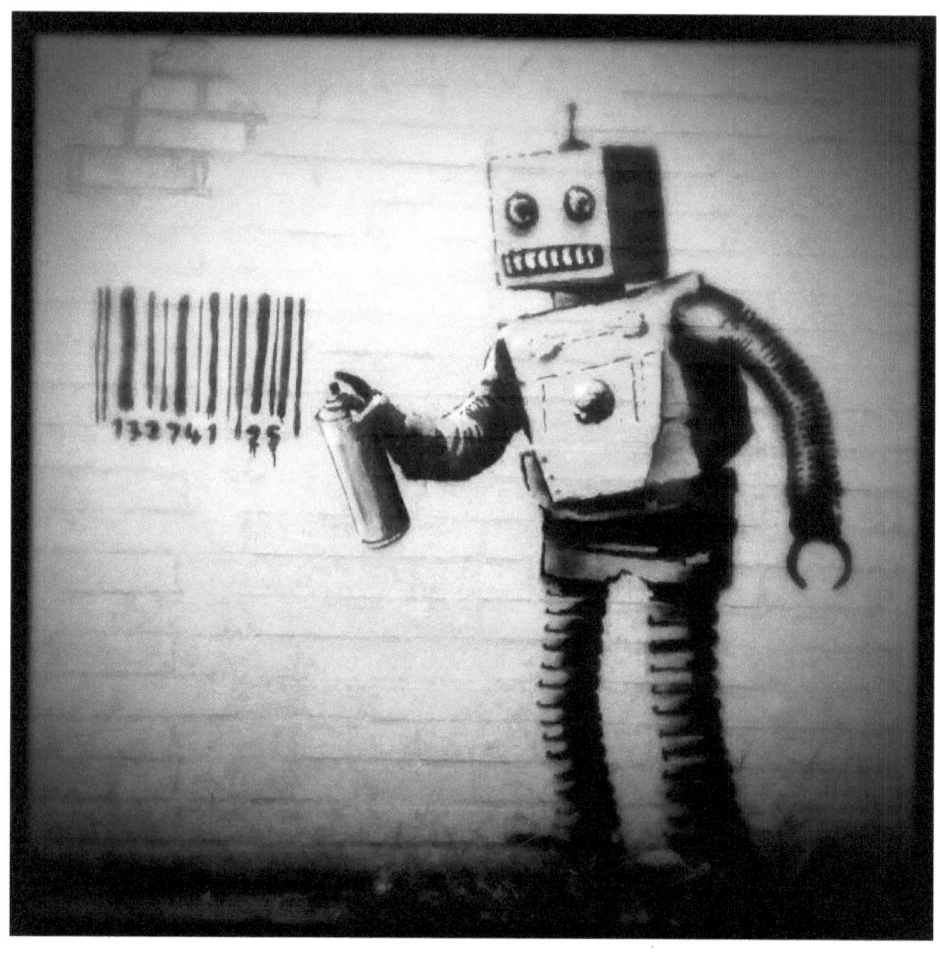

29 DAY 29, OCTOBER 29TH: THE BANALITY OF THE BANALITY OF EVIL

Love him or hate him, New Yorkers should have embraced this charitable soul on this day. Another extraordinarily brilliant play on Banksy's part. Banksy took a thrift store oil painting and painted a Nazi soldier onto it. According to the thrift store, Housing Works, on 23rd Street, someone came in and bought the original painting for $50 a couple of months before. On the 29th of October, it was returned and on Banksy's website, he wrote: "A thrift store painting vandalized then re-donated to the thrift store."

Housing Works is committed "to end the dual crises of homelessness and AIDS through relentless advocacy, the provision of lifesaving services, and entrepreneurial businesses that sustain our efforts." The painting sold at auction for $615,000 with all proceeds going to Housing Works.

The title of the piece apparently comes from a book written in 1963 by Hannah Arendt called "Eichmann in Jerusalem: A Report on the Banality of Evil," which documented a trial of a Nazi officer after WWll. The painting is signed by Banksy, as well as the original artist, "K. Sager."

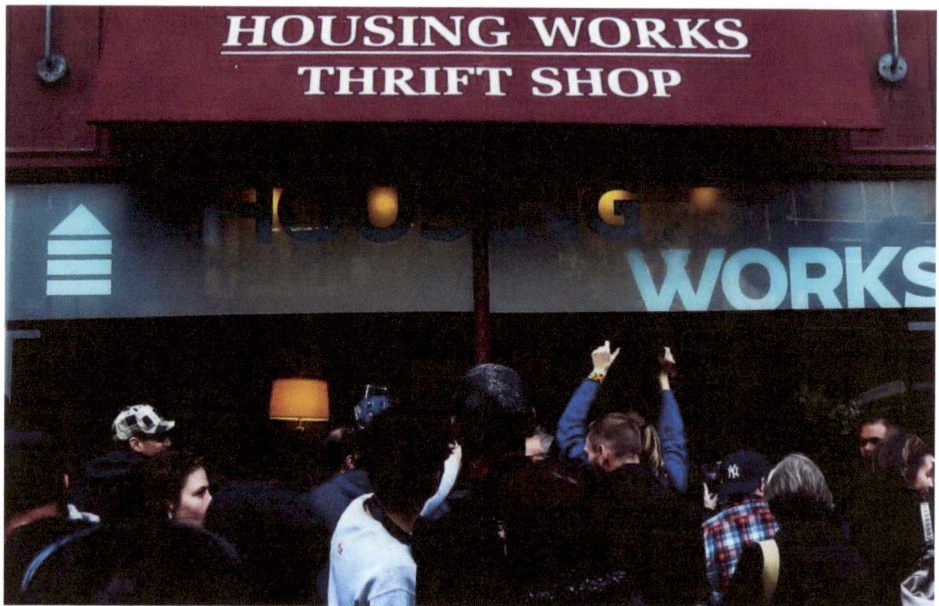

30 DAY 30, OCTOBER 30TH: THE BRONX ZOO

This one didn't get announced until really late on this day, so I wouldn't have been able to get a good picture of it. It looks like a leopard lounging on a railing and it is at Yankee Stadium. From 1972-1981, the New York Yankees were referred to as "The Bronx Zoo" because of all of the in-fighting between owner George Steinbrenner, manager Billy Martin, and star player Reggie Jackson. New Yorkers are massive sports fans, so this must have been Banksy's way of appealing to their passion. Showing yet again, that he has done his research. He didn't drop by New York accidentally. This was all strategically laid out.

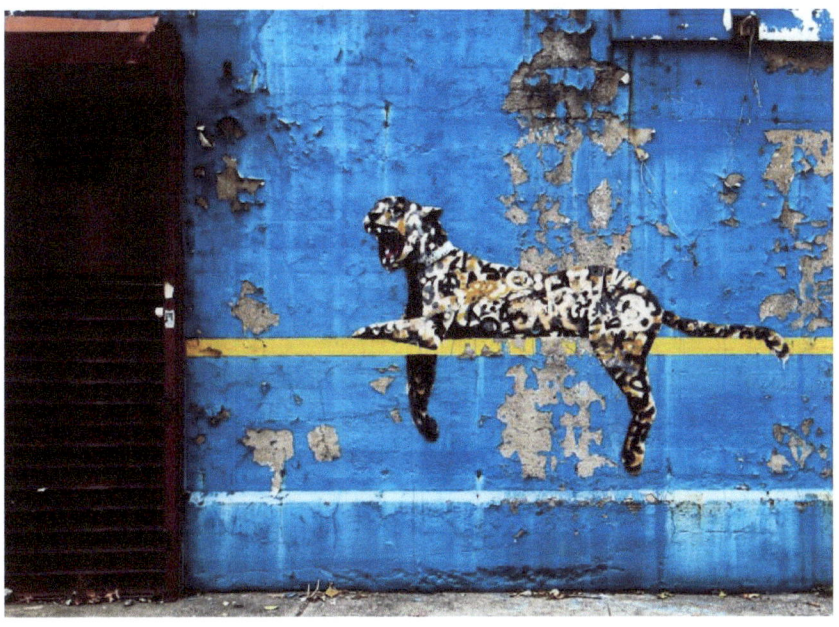

(photo courtesy of Banksy's website)

31 DAY 31, OCTOBER 31^(ST): INFLATABLE THROW-UP

Last piece of his residency. I have to admit, I was expecting something really huge, over-the-top, for the last day…but instead, Banksy just tagged his name in inflatable bubble letters on a building in Queens. And when you think about it, it's perfect. It was already gone by the time I had a chance to get out there.

(photo courtesy of Banksy's website)

ABOUT THE AUTHOR

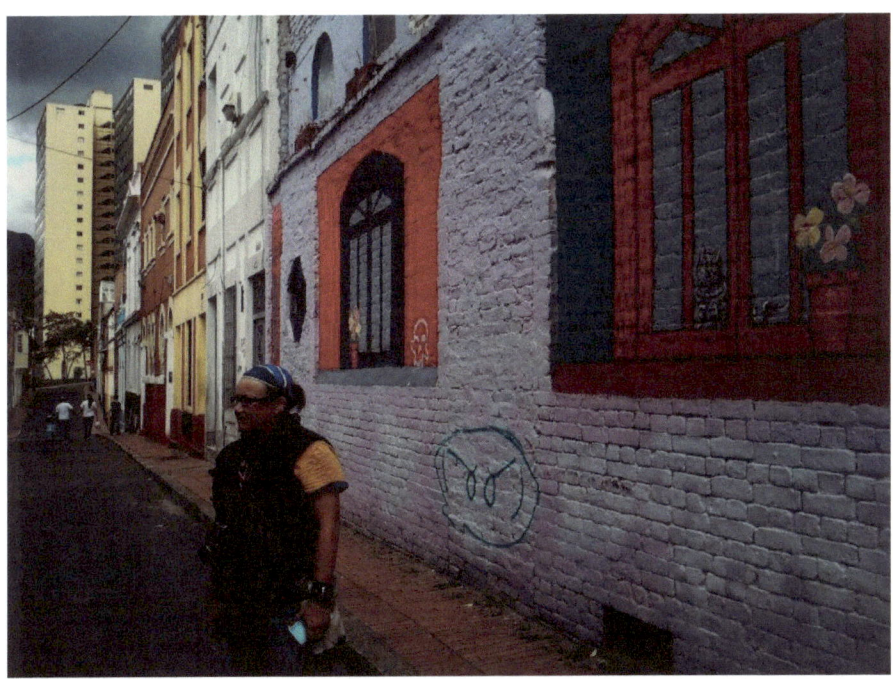

Pictured: Jacqueline Hadel in La Candelaria, in Bogota, Colombia. 2012. photo by Erica Lederman

Jacqueline Hadel is a solo world traveler who never goes anywhere without a camera. Her passion for urban art all over the globe is what motivates her to choose destinations based on the level of public art displays so that she can document it in-depth. She believes life is to be lived. So, she lives it.

www.ingramcontent.com/pod-product-compliance
Lightning Source LLC
Chambersburg PA
CBHW040842180526
45159CB00001B/281